PAGE 1: *Superman/Batman* #10 (July 2004) variant cover. DC's classic trinity of heroes in action in part three of Jeph Loeb and Michael Turner's "The Supergirl from Krypton." Inks by Scott Williams, colors by Alex Sinclair.

PAGE 2: Created for the cover of *The Official Overstreet Comic Book Price Guide*, 36th edition (May 2006, Random House). Pencils and inks on art board.

PAGES 4-5: Unproduced lithograph created for the Warner Bros. Studio Store gallery. Inks by Scott Williams, colors by Alex Sinclair.

PAGE 6: Pencils for the cover of *Batman* #615 (July 2003). Detail from the final cover was used on a United States postage stamp. Pencils on art board.

PAGE 7: This previously unpublished cover was created for the unreleased *WildCats* volume four, #2 (2006). Hadrian a.k.a. Spartan contemplates the power at his fingertips. Inks by Scott Williams, colors by Alex Sinclair.

Icons: The DC Comics and Wildstorm Art of Jim Lee

9781845765194
Diamond 9781845768300
Slipcase 9781845768317

Published by Titan Books
A division of Titan Publishing Group Ltd
144 Southwark Street, London SE1 0UP

First edition August 2010
10 9 8 7 6 5

All characters, their distinctive likenesses, and all related elements are trademarks of DC Comics. © 2010. All Rights Reserved.

Visit our website: www.titanbooks.com

ACKNOWLEDGEMENTS

Titan Books would like to thank all the people who have devoted their time, energy, and talent to creating this book, in particular Steve Korte, John Morgan, Andrea Shochet, and Frank Pittarese at DC Comics, Eddy Choi, Scott Williams, and Alex Sinclair at WildStorm, Paul Levitz, and Bill Baker. Special thanks also go to Elizabeth Bennett, Bob Kelly, Jean-Paul Rutter, Marcus Scudamore, Martin Stiff, and Kevin Wooff. But our greatest appreciation must go to the person without who this book literally could not exist, Jim Lee.

To receive advance information, news, competitions, and exclusive Titan offers online, please register as a member by clicking the "sign up" button on our website: www.titanbooks.com

Did you enjoy this book? We love to hear from our readers. Please e-mail us at: readerfeedback@titanemail.com or write to Reader Feedback at the above address.

No part of this publication may be reproduced, stored in a retrieval system, or transmitted, in any form or by any means without the prior written permission of the publisher, nor be otherwise circulated in any form of binding or cover other than that in which it is published and without a similar condition being imposed on the subsequent purchaser.

A CIP catalogue record for this title is available from the British Library.

Printed and bound in China.

ICONS

THE DC COMICS AND WILDSTORM ART OF
JIM LEE

TEXT BY
WILLIAM BAKER

TITAN BOOKS

CONTENTS

Introduction	8
Batman	12
Batman: Hush	22
Batman: Black and White	54
All Star Batman & Robin	60
Batman Family	88
Superman	96
Superman: For Tomorrow	104
Supergirl	126
Wonder Woman	128
Trinity	138
DC Heroes	142
WildStorm	154
WildC.A.T.s	156
Gen[13]	178
Divine Right	188
Deathblow	200
StormWatch	208
WildStorm Heroes	212
Vertigo	226
DC Universe Online	238
DC Logo	240
Gallery	252
Legion of Super-Heroes:	280
A Moment In Time	284
Bibliography	294
Acknowledgements	296

INTRODUCTION

JIM LEE was born in Seoul, South Korea on August 11, 1964. At the age of four his parents immigrated to the United States, and he grew up in St. Louis, Missouri—home of the Gateway Arch that serves as the entryway to the American Heartland—where he enjoyed a typical middle-class childhood. He was an avid artist, and a listing in his high school yearbook predicted that he'd work in comics.

Still, after graduation he entered the pre-med track at Princeton University, and for the next four years Lee believed that his future lay in the medical sphere, rather than the arts. All that changed in 1986 when, as he prepared to graduate with a psychology degree, Lee took an art class that rekindled his love of drawing. He rediscovered comics just as the medium underwent an unprecedented period of artistic growth and change, powered by the publication of such seminal graphic novels as Frank Miller's *Batman: The Dark Knight Returns* and *Watchmen* by Alan Moore and Dave Gibbons.

Deeply affected, Lee made the momentous decision to put his medical degree on hold and pursue a career in comics. He gained the reluctant blessing of his parents by allowing himself just one year to succeed, vowing that if he failed to find his place in the comics industry within that period he would choose to attend medical school.

Lee threw himself into his new career, learning as much as he could about the craft and business of comics while submitting art samples to various publishers. But it wasn't until he attended a New York comic convention that he received his first break. There he met the legendary editor Archie Goodwin, who invited the fledgling artist to stop by Marvel Comics, where Lee signed on for his first assignment.

OPPOSITE ABOVE: A convention promotional piece done in 2002 to promote the *Batman: Hush* storyline. Pencils and inks on art board.
OPPOSITE BELOW: Produced for the San Diego Comic-Con 2003's art auction. Pencils and inks on art board.
THIS PAGE: Jim Lee at a local exhibition, From Thought to Pop, for the Athenaeum, La Jolla, California. Photo by Victor Ha (2008).

ABOVE LEFT: Lee sketches for a fan at WonderCon 2009. Photo by Han Park.
ABOVE RIGHT: With the announcement that Paul Levitz was returning to write the ongoing *Legion of Super-Heroes* series, the WildStorm office drew this "Welcome Home" jam piece (October 2009), with Jim laying out the top half. Clockwise from top left: Sensor Girl and Colossal Boy (Jim Lee and Scott Williams), Quislet and Tellus (Carlos D'Anda), Lightning Lass (Jeff Martinez), Timber Wolf (Joel Gomez), Brainiac 5 (Richard Friend), Saturn Girl (Oliver Nome), Shrinking Violet (Sandra Hope), Cosmic Boy (JJ Kirby), Lightning Lad (Michael Lopez), Shadow Lass (Eddie Nuñez), Chameleon (Livio Ramondelli), and Ultra Boy (Trevor Scott). Pencils and inks on art board.
BELOW: A sketch of Rorschach from *Watchmen*. Pencils and inks on paper (2009).

He began on *Alpha Flight*, a mid-list title, then moved to a new book featuring the Punisher, where he began to be noticed by a growing fan base. A mere three years after entering the profession, he began illustrating issues of Marvel's premier series, *The Uncanny X-Men*, and soon was named that title's main artist. In 1991 his popularity was such that he was named co-writer and penciller of a new X-Men series.

In 1992, six of his fellow superstar artists left Marvel to form Image Comics. Enticed by the prospect of total control of his work, Lee accepted their invitation to join the new imprint, founding WildStorm Productions and launching an entire series of titles.

However, his role as publisher often interfered with his own creative inclinations. The resulting dissatisfaction fueled his decision to sell WildStorm to DC Comics in 1998, and made possible Lee's eventual return to monthly comics with the wildly successful *Batman: Hush* storyline, written by Jeph Loeb, which appeared in *Batman* and *Detective Comics* in 2003. It was followed by the *Superman: For Tomorrow* storyline in 2004, written by Brian Azzarello, and *All Star Batman & Robin, the Boy Wonder* in 2005, written by Frank Miller.

In February 2010, Jim Lee accepted the position of co-publisher of DC Comics. While this might have appeared to signal a move away from the creative side of comics, nothing could be further from the truth. A new monthly title, *Dark Knight: Boy Wonder*, was announced in spring 2010, and Lee committed himself to even greater creative involvement in the entire DC line, as well as championing DC's exploration of the many possibilities offered by the digital age.

ABOVE LEFT: Lee sitting at his drawing board in his offices at WildStorm central in La Jolla, California, 2007. Photo by Eddy Choi.
ABOVE RIGHT: Rough layouts of an illustration for "Last Man Standing," published in *Wizard* magazine #138 (March 2003).
THIS IMAGE: Detail of the final art. Colors by Alex Sinclair.

BATMAN

PREVIOUS SPREAD: Detail of *All Star Batman & Robin* #1 (September 2005) variant cover. Inks by Scott Williams, colors by Alex Sinclair.
LEFT: Pencils and ink wash on paper (2008). Colors by Alex Sinclair.
ABOVE: Undated Batman sketch. Inks on paper.
BELOW: Jim appeared at a comics symposium at the Pinocoteca Nazionale, in Bologna, Italy, in early 2005, and donated this piece to their Reggio Emilia fundraiser. Pencils, inks, ink wash, and Wite-Out on colored paper.
OPPOSITE: In a profile titled "The Korean-American Experience," Jim was featured in *KoreAm Journal* volume 14, #9 (September 2003). Colors by Alex Sinclair.

BATMAN was the second (after Superman) and the most fearsome of the original super heroes.

He was the boy who had everything, born into a life of privilege and ease, until the night his parents were violently taken from him, leaving him with a wound so deep that no amount of wealth could ever fill the gap. That event sent him on a path encompassing the globe in search of a vengeance tempered by justice.

He was created by Bob Kane—with help from Bill Finger—and since his first appearance in 1939, he has provided generations of readers with thrills and the hope for a better tomorrow.

"If Batman really existed, I think he'd be insane..." Jim noted. "To put on a cowl and fight crime in real life, even though you're a billionaire, you probably would need some medical attention, I would think. But in comic books, it works because you don't have to deal with those kinds of issues so directly."

Since joining DC, Lee has delineated various versions of Batman. Yet whether he's depicted him as the World's Greatest Detective, the Caped Crusader, or the Dark Knight, each of these visions remains true to Bob Kane's original conception—utterly unique and singular as a fingerprint.

LEFT: "Batman is a *great* character to draw as an artist. The environment the character's in is awesome. Gotham City's like another character within the book itself. It tests your ability to draw super heroes, your ability to create really moody shots, and the storytelling has to be top notch… You have to make it look powerful, even though he doesn't have blades that pop out of his hands or other nifty powers." Another early Batman piece finished before the start of the *Hush* series. Pencils and inks on art board (2002).

BELOW: These undated Batmobile sketches reveal a little known aspect of Lee's personality—the self professed "big car nut" who loves poring over concept car designs. Pencils on paper.

BOTTOM: Jim created this sketch for one of his cousins during a family gathering. Pencils, inks, and Wite-Out on colored paper.

OPPOSITE: Inspired by Christian Bale's performance in *The Dark Knight*, Jim drew Batman in the movie's armored look. Pencils, inks, and Wite-Out on art board. Colors by Alex Sinclair.

OPPOSITE INSET: Before coloring: pencils, inks, and Wite-Out on art board.

A 2004 sketch created for Jim's friend, the writer/artist Michele Petrucci, completed while attending a convention in Palermo, Sicily. Pencils, inks, ink wash, and Wite-Out on colored paper.
INSET: Partially inked Batman sketch. Pencils and inks on art board.
OPPOSITE: This image fully captures the mood and moment Lee sought to depict in the inset piece. Pencils, inks, and Wite-Out on art board (2008).

LEFT: These three sketches could be seen as Lee's reworking of a trio of iconic images associated with the Dark Knight. Pencils, inks, and Wite-Out on art board.

BELOW: Another study of Batman on one of Gotham's many rooftops. The colored paper sets a mid-tone to work both highlights and shadows into. Pencils, inks, ink wash, and Wite-Out on colored paper.

Paying homage to Frank Miller's *The Dark Knight Returns*, Jim's very first published Batman appeared in *Batman: Legends of the Dark Knight* #50 (September 1993). Pencils and inks on art board.

The cover art for the first printing of *Batman* #608 (December 2002). Inks by Scott Williams, colors by Alex Sinclair.

HUSH

BATMAN: HUSH was a watershed moment, and not only because it received rave reviews and achieved spectacular sales. More importantly for Jim Lee, it marked a long-sought return to his roots.

"In the aftermath of the sale of WildStorm to DC, there was a lot of stuff that just prevented me from doing a lot of drawing—even though one of my ultimate goals in the sale of the company was to return to the drafting table, specifically on a monthly book.

"But the right opportunity never presented itself. It had to be the right writer, the right character, and I had to have the time and the commitment to do what I wanted to do. I didn't want to do just a one-shot... I wanted to do a monthly book, and I wanted to have at least a twelve issue run on it."

Finally, everything fell into place in 2003.

"Fortunately, things were more settled down. My kids were a little older. All the business transaction stuff had been put to bed. So it was easier for me to find time at night or on the weekends to draw. And getting a chance to work with a writer like Jeph Loeb, who I'd say is arguably one of the best *Batman* writers of the past ten years, well it's something you just don't get to do every day... A lot of things had to happen, and they just all started coming together..."

Lee made the most of the opportunity.

ABOVE LEFT: This is the first Batman study Jim created after accepting the *Hush* assignment. Pencils and inks on paper.

ABOVE: Just another wet and bat-infested night in Gotham. Pencils, inks, ink wash, and Wite-Out on art board (2005).

THIS IMAGE: Detail of the cover of *Batman* #608, second printing (December 2002). Inks by Scott Williams, colors by Alex Sinclair.

ABOVE: Bruce Wayne experiences a critical moment of insight and inspiration, which leads to his assuming the mantle of his alter ego, "The Batman." Detail from the character's origin, as envisioned by creator Bob Kane and scribe Bill Finger, in *Detective Comics* #33 (November 1939).

BELOW LEFT: Jim's rough layouts for the second page of the retelling of the Dark Knight's origin, written by Jeph Loeb, which first appeared on DC Comics' website. Pencils on art board.

BELOW RIGHT: Lee's finished pencils for that same page. Pencils on art board.

OPPOSITE: The finished art of the second page of the Lee-Loeb version of Batman's origin, showcasing Jim's use of watercolors and the work of his artistic collaborators, inker Scott Williams and colorist Alex Sinclair, as it appeared on DC's website and in *Batman: Hush Volume One* (2003).

There would be no grieving for this child. No time would be lost wishing he could change these events.

There would only be the promise.

That very night, on the street stained with his mother and father's blood, he would make a vow to rid the city of the evil that had taken their lives.

It was, at best, a fool's errand, or so I told myself.

Using his family's wealth, Master Bruce sought out the world's greatest minds in criminology, martial arts, and the craft of detecting.

He knew that criminals are, by nature, a cowardly and superstitious lot.

They now call him The Batman.

In turn, he donned a cape and cowl and became a creature of the night, preying on those who broke the law.

But, I will always see him as that little boy, lost, struggling to find a way to make up for not being able to save his parents lives.

And I...? I can only offer him something I fear he sorely lacks.

Love.

ABOVE: The key event in young Bruce Wayne's life—the violent deaths of his parents during a mugging—from page eight of *Batman* #613 (May 2003). This showcases Jim's evocative use of watercolors to highlight the emotionally-charged nature of this memory. The two pairs of vertical lines indicate gutters that split the image into three distinct panels without separating them, subtly heightening the dramatic impact of the scene by slowing the reader's eye. Pencils, inks, and ink wash on art board. Colors by Alex Sinclair.

BELOW: A vision of a more innocent time when the Dark Knight often partnered with the Barbara Gordon incarnation of Batgirl, before she was crippled in a brutal attack by the Joker. This flashback occurs on page nine of *Batman* #614 (June 2003), during the Caped Crusader's beating of the Clown Prince of Crime. Pencils, inks, and graywash on art board. Colors by Alex Sinclair.

Batman imagines Catwoman's death at the hands of the Joker. This page was presented with minimal coloring on page 15 of *Batman* #614 (June 2003). Note the grinning visage of the Joker cast on the alley's two walls, on the building front seen over Batman's right shoulder, and on the face of the moon. Pencils on art board.

One of Batman's happier memories, this one featuring a rare rendition of a Golden Age character—the original Green Lantern—from page five of *Batman* #611 (March 2003). Asked about his role in creating the various flashback sequences in the *Hush* storyline, colorist Alex Sinclair said, "That's all Jim. Jim's doing full paintings. He's going straight to the art boards and painting on them. He scans it in and touches up stuff here and there. But on those flashbacks, it's about 98 percent Jim, and every now and then I'll jump in, or he'll ask me to do something. There was a flashback scene where young Bruce and Tommy watched the Golden Age Green Lantern fighting the Icicle, and I actually went in and did colorize some of what Jim had painted, to make Green Lantern stand out. But, for the most part, I get a file from Jim and he says, 'This is page eight,' and I just drop it in." Pencils, inks, and graywash on art board. Colors by Alex Sinclair.

ABOVE: Batman swings into action alongside the Jason Todd version of Robin in another flashback, from page 15 of *Batman* #618 (October 2003). Pencils on art board.
LEFT: The finished art for that same panel. Pencils, inks, and graywash on art board. Colors by Alex Sinclair.
BELOW: The third and last panel of page 15 from *Batman* #618. Unfinished pencils on art board.

29

PREVIOUS SPREAD: This panoramic view of the garage area of the Batcave, which houses various versions of the Batmobile from years past, appeared on pages 10 and 11 of *Batman* #615 (July 2003). Pencils on art board.

OPPOSITE ABOVE: Lee's rough layout for a savage encounter between Catwoman and the Huntress. "Sometimes you find yourself gritting your teeth while you're drawing, or snarling or something. To me, that's a good sign, because that means that I am trying to imagine the scene that I'm drawing, that I'm trying to imagine the emotional state of the characters I'm trying to draw." Pencils, pens, and markers on paper.

OPPOSITE BELOW: The final art, from pages 12 and 13 of *Batman* #617 (September 2003), wholly captures both the violence and the full range of emotion inherent to their confrontation. Inks by Scott Williams, colors by Alex Sinclair.

THIS PAGE: The sweetest fruit is always that which is forbidden. Batman and Catwoman share a private moment on page 22 of *Batman* #610 (February 2003). Inks by Scott Williams, colors by Alex Sinclair.

LEFT: Unused rough cover design for *Batman: Hush Double Feature* (2003), collecting *Batman* #608 and #609. Pencils and markers on paper.
LEFT MIDDLE AND BOTTOM: Jim typically offers editors multiple ideas for each issue's cover. These are two studies for the cover of *Batman* #610 (February 2003). Pencils and markers on paper.
BELOW: Detail of the final cover art for *Batman* #610. Colors by Alex Sinclair.
OPPOSITE: This undated study of ecoterrorist Poison Ivy captures both her sultry allure and smoldering anger. Pencils, inks, ink wash, and Wite-Out on art board.
OPPOSITE INSET: The cover of *Batman* #609 features the Caped Crusader flanked by two women, one who would steal his freedom, and the other who would steal his heart. Colors by Alex Sinclair.

LEFT INSET: Lee's rough for the cover of *Batman* #612. Pencils and markers on paper.

THIS IMAGE: Detail of Jim's final pencils for that same issue's cover. Note the changes between this and the rough sketch, including the angle of Batman's head and the placement of his left hand. Pencils on art board.

The finished cover for *Batman* #612. Inks by Scott Williams, colors by Alex Sinclair.

WOULD TALIA BE IN THIS SHOT?

ABOVE AND TOP RIGHT: Two unused cover designs for the "Heroes" gatefold cover for *Batman* #619 (November 2003). The issue, which presented the final installment of the *Hush* storyline, was released with two covers, one featuring the extended "Batman Family" and the other the Caped Crusader's "Rogues Gallery" of villains. "I'll do anywhere from two to six, so there's lots and lots of cover sketches for every one used. But I try not to just come up with them for the sake of coming up with them. I'm not going to turn in four if I only have three ideas. But sometimes I have six ideas. Usually, when you get to six, a couple of them are variations of ones you have, where you're coming in closer or pulling out further." Pencils and markers on paper.

RIGHT: Lee's rough sketch of the "Villains" gatefold cover for *Batman* #619. Pencils and markers on paper.

OPPOSITE TOP: The final "Heroes" art for the gatefold cover of *Batman* #619. Inks by Scott Williams, colors by Alex Sinclair.

OPPOSITE BOTTOM: The "Villains" gatefold cover for that same issue. Inks by Scott Williams, colors by Alex Sinclair.

OPPOSITE: Jim's pencils for page five of *Batman: Hush* "Interlude: The Cave," a five-page tale originally presented in *Wizard* #0 (July 2003). It appears in its proper place, wedged between *Batman* #616 and #617, in *Batman: Hush Volume Two*. Pencils on art board.
THIS PAGE: Final art of that same page. Inks by Scott Williams, colors by Alex Sinclair.

This evocative image graces the cover of the *Batman: Hush Volume Two* paperback edition (2004). Pencils, inks, ink wash, markers, Wite-Out and Wite-Out toothbrush spatters on colored paper.

ABOVE: This piece appeared on the cover of the first paperback edition of *Batman: Hush* (2004). Pencils, inks, ink wash, Wite-Out highlights and spatters on colored art board.
BELOW: Several of Jim's thumbnail designs for the *Batman: Hush* hardcover collections. Pencils, inks, markers, and Wite-Out on paper.
RIGHT: The final cover for the hardcover edition of *Batman: Hush Volume One* collection (2003). Pencils, inks, ink wash, and Wite-Out on paper. Colors by Alex Sinclair.

LEFT: These two vertical panels, which were incorporated as design elements in the covers of the two hardcover *Batman: Hush* collections, each feature headshots of the villains who make prominent appearances in each half of the story. The piece topped with Superman's visage appeared on the first volume's cover, while the image featuring the Dark Knight's portrait is part of the cover for volume two. Pencils, inks, ink wash, and Wite-Out on art board. Colors by Alex Sinclair.

THIS IMAGE: This art appears on the *Absolute Batman: Hush* dustjacket (2005). Pencils, inks, ink wash, and Wite-Out on art board. Colors by Alex Sinclair.

LEFT: This sketch, based upon one of the recurring iconic poses assumed by the Dark Knight over the years, appears on the endpapers of the *Absolute Batman: Hush* collection (2005). Pencils on art board.
BELOW LEFT: This final art for the cover of a special promotional edition of *Batman* #608 (December 2002), also saw life as a retail display poster. Inks by Scott Williams, colors by Alex Sinclair.
BELOW: The cover art for the promotional version of *Batman* #608, shown at two stages of its completion. Pencils on art board.

BELOW LEFT: This sketch was used as solicitation art for the DC Direct action figure line based on the *Hush* story arc. Pencils on art board.
BELOW RIGHT TOP: Just one example of the highly detailed sketches and notes Jim exchanged with the DC Direct sculptors while working on perfecting the look of the *Hush* action figures. "You just work with it until they start internalizing how you construct and build figures. So it's an interesting experience and an interesting process, because it actually makes you think about why you do the things you do stylistically, and it helps you understand your *own* style better, because to communicate it, you have to understand it *completely*." Pencils on paper.
BELOW RIGHT BOTTOM: Reference drawing of the profiles of some of the characters included in the *Hush* line of action figures. Pencils on art board.

The final version of the Batman figure from the DC Direct *Hush* Series One line (May 2004) was sculpted by Tim Bruckner, based upon designs by Jim Lee.

THIS PAGE: Jim's designs for six of the action figures from the DC Direct *Hush* line. Clockwise from upper left: Robin (unproduced), the Riddler, the Huntress, Harley Quinn, Hush, and Superman. Pencils on art board.
OPPOSITE: The final versions of four action figures from the *Hush* Series One line, sculpted by Tim Bruckner and based upon Jim's designs. Clockwise from upper left: Poison Ivy, the Huntress, Hush, and the Joker.

LEFT: Catwoman unsheathes her claws in this image from page 11 of *Batman* #614 (June 2003). Inks by Scott Williams, colors by Alex Sinclair.
ABOVE: One of the unused sketches Jim created while working on the DC Direct *Hush* Catwoman statue. Pencils on art board.
BELOW: A series of unused designs for the *Hush* Catwoman statue. Pencils on paper.

The final version of DC Direct's *Hush* Catwoman statue was sculpted by Jonathan Matthews, based upon Jim Lee's designs, and released in August 2005. It was limited to 3,500 copies.

BLACK AND WHITE

JIM Lee's first story featuring the Caped Crusader appeared three years prior to *Hush*, and yielded some of the most unique images of the character he ever produced.

First conceived in 1996 as a miniseries, *Batman: Black and White* was an anthology title featuring original tales written and drawn by some of the best and brightest creators in the medium, most of whom had never before worked on the Dark Knight. Jim supplied the art for the first issue's cover and, as the title indicates, it was all done in black and white, a rarity for DC.

But the idea proved so popular that it spawned a second miniseries, and eventually DC adapted the concept and began including short black-and-white tales developed as backup stories in one of their ongoing titles, *Batman: Gotham Knights*. That led to Lee's first Batman story, "To Become the Bat," featuring a script by Warren Ellis and appearing in the back pages of *Batman: Gotham Knights* #1 in 2000.

"It's fun to be able to participate in something like that, to get on an iconic character and show people your take on it," Lee commented. "And also, it's an honor, really, to be part of the pedigree, part of the history, as one of the artists who have worked on the character—a line that goes back to Jerry Robinson, and Bill Finger, and all the way back to Bob Kane himself."

Jim penciled and inked all eight pages of "To Become the Bat," which originally appeared as a backup story in the first issue of *Batman: Gotham Knights* (March 2000), including this image—page five of the story. Pencils and inks on art board.

Warren's script is essentially a murder mystery, and places the primary focus on the "World's Greatest Detective" aspect of the character. Page one is shown here. Pencils and inks on art board.

ABOVE: "When I ink myself, I tend to spot more blacks. Instead of having a gray value that I'll create by having a lot of cross-hatched lines, I sort of change my style to a simpler, straight black and white-type of style. So I'll spot a lot more blacks and, consequently, the work comes out more graphic, more powerful." The results of this approach are fully displayed in this moment from page four of "To Become the Bat." Pencils and inks on art board.

RIGHT: The full intensity of the Dark Knight's quest for justice is captured in this close-up from page three. Pencils and inks on art board.

The present and past collide for the Caped Crusader in this sequence found on page three. Pencils and inks on art board.

57

INSET: Lee's rough cover sketch for *Batman: Black and White* #1 (June 1996). Pencils and markers on paper.
THIS PAGE: Jim's finished art for the cover. Pencils and inks on art board.

ABOVE LEFT: A sampling of Lee's initial rough design sketches for the *Batman: Black and White* statue. Pencils on paper.

ABOVE RIGHT: "Working on a statue with a sculptor, it's akin to penciling a page for an inker. They're always going to have their own style that infuses the piece—their own sense of proportions, the way they sculpt hands and wrists, and bring power to the form. So every one you do with a different sculptor is a different kind of project. It's almost like you have to translate your style and explain it to another artist, so that he can translate it into his style and output something that resembles your style." An unused design for the *Black and White* statue. Pencils and inks on art board.

BELOW: The *Batman: Black and White* statue sculpted by Erick Sosa, based upon designs by Jim Lee, was released by DC Direct in 2007. The run was limited to 5,000.

All Star Batman & Robin issue 6, page one. Inks by Scott Williams; colors by Alex Sinclair.

Dick Grayson experiences an up close and personal moment with the Dark Knight on page 22 of the first issue of *All Star Batman & Robin* (September 2005). Inks by Scott Williams, colors by Alex Sinclair.

ALL STAR BATMAN & ROBIN

One of Lee's design sketches of the *All Star* Guardian of Gotham City. Pencils and inks on art board.

LEE'S next major project featuring the Caped Crusader presented a darker rendition of the character.

Lee's creative partner on *All Star Batman & Robin, The Boy Wonder* was the legendary Frank Miller, a creator famous for challenging his audience's expectations of both the medium and its icons.

"Frank, being Frank, he's not going to do the expected," Jim commented. "He's going to listen to his inner voice and let his creativity guide the project. And what we got was a character that was very raw.

"But this is supposed to be part of the Dark Knight continuity that includes [*Batman:*] *Year One*, and *The Dark Knight Returns*, and *The Dark Knight Strikes Again!* So I think that Frank was approaching it from that point of view."

Ultimately, Lee sees no disconnect between this particular portrayal and other, more traditional versions of the character.

"You know, Batman can't be the same at every age and period of his life. And I think Frank's trying to show us what Batman was like in his prime, right before he added Robin, and how that addition affects and changes him.

"In fact, at the end of the first story arc, you see how Batman accepts the fact that he's got someone to protect now—that, in essence, he has a ward and he has a son. And that means he's more of a role model, and that inspires him to change."

- LONGER, LEANER BODY
- SPIKIER FOREARMS

TEMPLE STITCH LINE WRINKLES OVER SOLID PHYSIQUE...
STITCHES ALONG CHEST, ELBOWS, TRUNKS

ABOVE: Two more of Jim's unused designs for the *All Star* Batman. Pencils and inks on art board.
BELOW: Detail of the raw pencils for the cover of the second issue of *All Star Batman & Robin* (November 2005). Pencils on art board.

- LONG EARS
- BLACK CAPE, HELM, CHEST, SHOULDERS, GAUNTLETS, BOOTS, COD-PIECE
- YELLOW INSIGNIA, BELT

ABOVE: A few more of Jim's attempts to establish a costume with the perfect fit for this version of the Dark Knight. Pencils and inks on paper.
BELOW: Detail of the finished cover for the second issue of *All Star Batman & Robin* (November 2005). Inks by Scott Williams, colors by Alex Sinclair.

- GOGGLES
- CHAINMAIL SHIRT
- DK GREEN OUTSIDE OF CAPE - BRIGHT YELLOW INSIDE
- HOOD

- MOTORCYCLE BOOTS

ABOVE: Three of Lee's design sketches of the *All Star* Robin's costume. Pencils and inks on art paper.
BELOW: Dick Grayson before his life is shattered by an act of violence in this detail from an unused layout of the splash panel which opened the series' first issue. Pencils on art board.

- OAKLEY STYLE GLASSES no headband

- STRIPES ON OUTSIDE OF PANTS?

- ARMOR CHEST, HIPS, SHOULDERS, FOREARMS
- HOOD

ABOVE: Two more examples of Lee's unused redesigns of the Boy Wonder's costume for the *All Star* run. Pencils and inks on art board.
BELOW: Detail from the opening splash page of the first issue of *All Star Batman & Robin* (September 2005). Inks by Scott Williams, colors by Alex Sinclair.

This panel found on page nine of issue 5 (July 2007) captures the real satisfaction that Batman gets from his work. Pencils on art board.

Lee asserts that, with Miller's *All Star* version of the Dark Knight, "What we got was a character that was very raw. It resonated with a lot of fans. They loved the over-the-top nature of this character. What I think fans didn't initially realize is that this take on Batman is something that is tempered by the addition of Robin to his mythology and to his team." This visceral portrait of the man in question appeared on the cover of the series' fifth issue (July 2007). Inks by Scott Williams, colors by Alex Sinclair.

ABOVE: Six of Jim's thumbnail designs for the cover of the first issue of *All Star Batman & Robin* (September 2005). Markers on paper.

ABOVE RIGHT: Detail of the "solo Batman" cover A (the "solo Robin" cover B is not featured here) to the first issue of *All Star Batman & Robin* (September 2005). Inks by Scott Williams, colors by Alex Sinclair.

RIGHT: Detail of the "Dynamic Duo" cover of the *All Star Batman & Robin, The Boy Wonder* volume one collection (June 2008). Jim actually drew each cover separately and they were composited together for the final collection. Pencils on art board.

OPPOSITE: A slightly cropped version of the final art for the "Dynamic Duo" cover, sans logos and trade dress. Inks by Scott Williams, colors by Alex Sinclair.

68

The Dark Knight races across the rooftops of Gotham, reveling in his abilities and power in this double page spread seen on pages 10 and 11 of the series' fifth issue (July 2007). Inks by Scott Williams, colors by Alex Sinclair.

This was the first *All Star* image Jim drew, exclusively for *Wizard* magazine #160 (February 2005). Note the various differences in both characters' costumes between this and the facing page, including Robin's altered gauntlets and footwear and the different designs for Batman's chest insignia and glove flares. Pencils and inks on art board.

OPPOSITE: The Dynamic Duo leap into action together for the first time in this image from page seven of issue ten of *All Star Batman & Robin* (August 2008). Pencils and inks on art board. Inks by Scott Williams.

BATMAN ROBIN 10 PG 7

THIS PANEL TOOK 2.5 HOURS...

Lee's pencils for page 19 from the second issue of the series (November 2005) showcase his ability to pace and render a series of "talking heads" shots in a dynamic manner. Pencils on art board.

This finished art from page 20 of the same issue highlights the subtle and bold ways that the work of inker Scott Williams and colorist Alex Sinclair breathe further definition and life into Jim's pencils.

The two-page spread covering pages 16 and 17 in the second issue of *All Star Batman & Robin* (November 2005) provides the reader not only with some wildly extravagant pyrotechnics, but also with a much-needed release of tension following the emotionally-charged events that came before. Inks by Scott Williams, colors by Alex Sinclair.

BELOW: The series presented Jim with the challenge of learning to draw believable animals, such as the leaping doe and faun found on pages 16 and 17 of issue 9 (April 2008). "Frank likes to include a lot of animals in his scripts. So, there are all these shots of rabbits and deer and lizards and rats, and he uses them in juxtaposition with the images which are the main focus of the panels. They're not critical to the storyline, but they are artistic storytelling devices. And every time I draw one of those critters, it's usually for the first time, so that requires a lot of Googling and finding reference, and just trying to figure out how these animals are constructed. You know, there's a lot of muscle construction that's similar to humans, but in different proportions, and so it's just like learning how to draw all over again." Pencils on art board.

ABOVE: The Black Canary proves that she's a bird of prey on pages six and seven of *All Star Batman & Robin* #3 (December 2005). Inks by Scott Williams, colors by Alex Sinclair.

THIS IMAGE: Early designs for the *All Star* Black Canary hearken back to a variety of sources, including the celebrated Denny O'Neil and Neal Adams run on the *Green Lantern/Green Arrow* series. Pencils and inks on art board.

OPPOSITE BOTTOM RIGHT AND THIS PAGE: The initial layout and finished pencils for page three of the third issue (December 2005) provide some real insight into Lee's creative process.

"I'll block everything in. I'll rule out the panels, and then I put in all the shapes very loosely with gestural drawings. Then I lightly erase everything, and then I go back in and re-pencil on top of those drawings. As you put something very dark down next to a very light pencil line, your eye sort of auto-contrasts that and you don't really see the light pencils anymore, so the dark lines come to the fore. So you almost have a blueprint underneath your actual drawing that you're working on. This way, you're composing your shot, and you've got your negative spaces worked out." Pencils on art board.

THIS PAGE AND OPPOSITE TOP LEFT: Captain James Gordon enjoys a cigarette on the docks of Gotham City, from page one of the tenth issue of *All Star Batman & Robin* (August 2008). Note how both Williams's inks and Sinclair's coloring serve to heighten the noir-inflected sensibilities of Lee's pencils.

ABOVE RIGHT: Lee's rough designs for the *All Star* Joker (top) and Mister Freeze. Pencils and inks on paper.

THIS IMAGE: Lee's design sketches of, left to right, Zatanna, Green Lantern, the Question, and Green Arrow. Pencils and inks on art board.

81

MAIN IMAGE: The Dynamic Duo hitch a ride on one of Gotham's subway trains in this pulse-quickening double page spread found on pages ten and eleven from *All Star Batman & Robin* #10 (August 2008). Pencils on art board.

THIS IMAGE: Detail of the final art for those same two pages. Williams and Sinclair's work sharpens the focus on the characters even as it enforces the sense of depth and speed inherent to Lee's original art. Inks by Scott Williams, colors by Alex Sinclair.

Detail of the final art for the cover of the eighth issue of the series (January 2008). Inks by Scott Williams, colors by Alex Sinclair.
OPPOSITE TOP LEFT: The Joker leaves the scene of his latest crime on page five of *All Star Batman & Robin* #8 (January 2008). Inks by Scott Williams, colors by Alex Sinclair.
OPPOSITE TOP RIGHT: Despite his winning smile, the Joker is definitely not the kind of clown you want at your birthday party. This piece was a gift from Jim to Heath Ledger on behalf of Warner Bros. Pencils and watercolors on art board (2007).
OPPOSITE BOTTOM: There's no mistaking the murderous intent of the Clown Prince of Crime in this detail from the second panel on page four of issue 8. Inks by Scott Williams, colors by Alex Sinclair.

Lee's pencils for the cover of issue nine (April 2008) feature yet another reworking of an iconic image of the Dynamic Duo. This is an homage to Jack Burnley's cover for *Batman* #9 (February/March 1942). Pencils on art board.

The finished cover art for that same issue. Inks by Scott Williams, colors by Alex Sinclair.

The *All Star Batman & Robin* statue (August 2006) from DC Direct was sculpted by John G. Mathews, based upon Jim Lee's designs. This piece had a limited run of 1,300.

Jim drew this for *Wizard* magazine #168 (October 2005), as an homage to the classic 1966 image of the Dynamic Duo by Carmine Infantino and Murphy Anderson. Inks by Scott Williams, colors by Alex Sinclair.

ABOVE LEFT: A jam piece featuring Batman with some of his modern-day allies, clockwise from top: Azrael (Carlos D'Anda), Batman (Jim Lee), Tim Drake as Robin (Alé Garza), and Nightwing (Lee Bermejo). "We all inked our work but had to have some ringers—Scott Williams, Sandra Hope, Richard Friend; all inkers supreme!—come in and fix some of the haggard lines we threw down." *Jim Lee Sketchbook* (2003). Pencils and inks on art board.

ABOVE RIGHT: The other half, this time featuring the important women in the Dark Knight's life, clockwise from top: the Huntress (Carlos D'Anda), Batgirl (Jim Lee), Catwoman (Lee Bermejo), and Harley Quinn (Alé Garza). Pencils and inks on art board.

THE BATMAN FAMILY

"YOU shall judge a man by his foes as well as by his friends." Joseph Conrad wrote that in his famous novel, *Lord Jim*.

Over the course of seven decades, the Dark Knight has accumulated what is widely considered to be the ultimate Rogues Gallery—a "best of the worst" roll call that counts among its members such iconic villains as the Joker, the Penguin, Catwoman, the Riddler, and Poison Ivy.

The Caped Crusader's friends and allies are equally noteworthy, and include icons such as Robin, Batgirl, Commissioner Gordon, and Alfred, Bruce Wayne's butler and confidant. These characters have been so popular in their own right that they spawned a twenty-issue *Batman Family* title in the mid-70s.

For Batman's supporting cast, the exposure through other media has been considerable, especially animated and live-action television shows. The original live television show of the 1960s did much for the broader public's knowledge of Catwoman, the Joker, the Penguin, and even the Riddler, who was considered a minor character before Frank Gorshin's portrayal. Later animated series helped popularize other nefarious characters including Clayface, Two-Face, and Harley Quinn, created as the Joker's sidekick for *Batman: The Animated Series*. Harley proved so popular that she was written into comic book continuity.

Each artist has his or her own favorites, and Jim Lee is no exception. He's expressed a particular fondness for the Joker, Catwoman, and Poison Ivy... and it shows in the attention he gives them at his drawing board.

Barbara Gordon as Batgirl. Pencils, ink, and Wite-Out on art board (2009).

LEFT: A full-length portrait of the Gordon-era Batgirl. Pencils, inks, ink wash, and Wite-Out on paper (2004).
ABOVE TOP: Another image featuring the Silver Age (1960s) Batgirl. Pencils, inks, markers, and Wite-Out on art board (2006).
ABOVE: The modern-day Batgirl, Cassandra Cain, done in pencils on paper.

89

According to Jim, "Catwoman has played a very interesting role as a supporting character in the Batman mythos." This lush portrait of Gotham's foremost feline burglar was crafted in pencils, inks, and Wite-Out on art board (2008).

JIM LEE
2008

RIGHT: The *All Star* Black Canary in raw pencils, and the fully realized image in pencils and inks on art board (2009).
BELOW: Yet another take on that perennially popular character, this one in pencils and inks on paper.
BELOW RIGHT: The Silver Age Black Canary, using her patented "sonic scream" on an unseen enemy. Pencils, inks, and Wite-Out on art board.
OPPOSITE: Dick Grayson as Nightwing, the heroic persona the original Robin assumed after growing out of his "Boy Wonder" moniker. Pencils and inks on art board (2003).

In Lee's opinion, "Batman has the best Rogues Gallery in comic books, bar none... In some ways, the villains are more fun to draw than the main character himself. Also, I think every Batman run should have a Joker story in it, somewhere." This particularly manic portrait of the Joker was done in pencils, inks, ink wash, watercolors, and Wite-Out on art board.

LEFT: Every great hero is best defined by a villain who is, in a very real sense, his evil twin. Pencils, inks, ink wash, and Wite-Out on art board (2007).
BELOW: The Joker gets the drop on the Dark Knight. Pencils, inks, ink wash, markers, and Wite-Out on colored paper (2004).

SUPERMAN

HIS name is Superman, and his story is one that's as old as Moses, yet as modern as the scientific age. He is the first and arguably the most famous of the super heroes.

The last son of the planet Krypton, he was born to parents who, knowing their planet was doomed, entrusted their infant son to the empty reaches of outer space with the hope he would escape extinction. By sheer chance his small ship landed in the bosom of the American Midwest, to be discovered by a childless couple who raised him as their own. Gifted with abilities far beyond those of mere mortals, he was taught to respect life, liberty, and the ultimate redemption that love, kindness, and good deeds offer to all.

He was created by Jerry Siegel and Joe Shuster, a pair of teenagers from Cleveland, Ohio, and since his first appearance in 1938 he has provided both entertainment and inspiration to generations of readers.

"The thing with Superman is that he's the ultimate hero," Jim observed, "and he needs to be celebrated in that way, made into a figure that today's audience will look up to and accept before saying to themselves, 'You know what? He's who I aspire to be.'"

From the first time he drew the character years ago, Lee sought to reshape the image of DC's central icon for the 21st century. It was a challenge he accepted with relish.

PREVIOUS SPREAD: Detail of the first panel of page 15 from *Superman* volume two, #206 (August 2004). Inks by Scott Williams, colors by Alex Sinclair.
RIGHT: A very early Superman sketch by a young Jim Lee, influenced by *Batman: The Dark Knight Returns*. Inks and markers on paper.
THIS SPREAD: Dissatisfied with his portrayal of Superman in *Batman: Hush*, Lee set about rediscovering the character's visual essence through doodles, sketches and even breaking down his figure into its basic components, all in an effort to better understand how to build a better Man of Steel for the *For Tomorrow* run. Pencils, inks, and markers on paper.

98

99

ABOVE: Eight of Jim's unused rough cover designs for *Wizard* magazine #150 (April 2004), celebrating the start of the *Superman: For Tomorrow* run. Pencils and markers on paper.
BELOW INSET: Lee's final pencils for that *Wizard* cover. Pencils on art board.
BELOW: The final cover art for *Wizard* magazine #150 (April 2004). Inks by Scott Williams, colors by Alex Sinclair.

INSET: Lee's figure and layout designs for the "Legendary Heroes" *Wizard* cover collaboration with the popular painter Alex Ross. Pencils on paper.

THIS PAGE: The completed "Legendary Heroes" artwork, featuring Alex Ross's painted rendition of Jim's drawing. Originally created as an exclusive cover for *Wizard* magazine #155 (September 2004), it also was released as a limited edition Giclee print in April of 2006.

OPPOSITE: A dramatic look at Superman flying through the void of space, from *JLA-Z* #3 (January 2004). Pencils on art board.
ABOVE: Detail of Lee's homage to the iconic Neal Adams cover for *Superman* volume one, #233 (January 1971). Colors by Alex Sinclair.
BELOW: The slipcase and dustjacket art, respectively, for the *Absolute Superman: For Tomorrow* collection (April 2009). Pencils and inks on art board.

This image of a resolute Man of Steel appears on page 15 of *Superman* volume two, #205 (July 2004). Inks by Scott Williams, colors by Alex Sinclair.

FOR TOMORROW

EVEN before DC announced that he'd follow up the phenomenally successful *Batman: Hush* with a year's run on *Superman*, Lee was well aware of the conundrum he'd have to confront.

"Everyone always says, 'He's the ultimate Boy Scout.' But he doesn't have to be, and every time someone writes him as being something less than pure, something less than the idealized version of humanity, people go, 'Oh, that's not Superman!' So, in a sense, our desires to update him and bring him into the 21st century are stymied by our own internal preconceptions of who the character is."

Lee's creative partner on the project, celebrated scribe Brian Azzarello (*100 Bullets*), provided his own unique way of addressing this paradox.

"He went inwards rather than outwards, meaning he thought about the character, his life story, his history, as opposed to who he's going to punch and who he's going to battle," Jim explained.

"Instead, he really focused on Superman's relationship with Lois, and the fact that, like Batman, he's a character who lost his father extremely early... That's something that Brian knew and felt was universal. And that's how you can take a character that is supposed to be an ultimate example of humanity and make him something that everyone can understand and sympathize with."

The resulting tale, *Superman: For Tomorrow*, brought a fresh perspective and did much to humanize the character, while tweaking his classic look for a new generation.

ABOVE: The Man of Tomorrow encounters a world of perfection in this panel on page nine of *Superman* #212 (February 2005). Inks by Scott Williams, colors by Alex Sinclair.
LEFT: A turnaround of Superman Jim created to codify the Man of Steel's appearance in *For Tomorrow*. Pencils and inks on art board.

SUPERMAN 1.0 TURNAROUND 11-20-02

Two of Lee's early sketches of Superman, in which he attempted to capture the character's power and speed in two dimensions. These were showcased in *Superman* #203 (May 2004), illustrating Jim's development for his run on the book. Pencils, inks, Wite-Out, and markers on paper.

OPPOSITE TOP: More sketches, these done as part of the process of nailing down the precise shape of Superman's head, face, and limbs. Jim's notes, particularly those regarding any similarities to his version of Bruce Wayne, reveal an urge to craft a unique look for his Man of Steel. Pencils, inks, and markers on art board.

MORE JAW
MORE PUG NOSE

TOO CARTOONY?

BUCKLE DETAIL?

NOT HIGH CUT?

VEINY HANDS

← Lee Bermejo designed sleeves? ???

WAVIER HAIR THAN BRUCE

MORE ROUNDED CHIN THAN BRUCE

STILL TOO CLOSE TO BRUCE

RIGHT: This portrait of the Man of Steel is from page 18 of *Superman* #210 (December 2004), and shows the end result of Jim's development on the character. Inks by Scott Williams, colors by Alex Sinclair.

ABOVE: Father Daniel Leone encounters the Man of Tomorrow for the first time on page six of *Superman* #204 (June 2004).

RIGHT: "In any design or drawing, if you are going to add shadows, you have to decide whether the shadow only affects certain colors—say, Superman's blues and reds—or if it will be more real-life shadows and cut across all elements—for example, Superman's chest emblem. The problem with the latter is that you are obscuring his world-famous chest symbol, which is probably the most powerful element of his costume. Pencils, inks, markers, and Wite-Out on board (2004).

LEFT AND RIGHT: Jim's rough layouts for the two-page version of Superman's origin, originally presented online before being included in the *Superman: For Tomorrow Volume One* collection. Pencils on board.

BELOW: The Last Son of Krypton relives his deliverance from the destruction of his home world on page nine of *Superman* #213 (March 2005). Inks by Scott Williams, colors by Alex Sinclair.

The finished pencils for *Superman* #209's cover (November 2004). Pencils on art board.

ABOVE: Throughout his career, Lee has incorporated visual and textual nods to the work of other creators, past and present, including this homage to the cover of the first issue of *Superman*, drawn by co-creator Joe Shuster, from *Superman* volume two, #204, page 23 (June 2004). Inks by Scott Williams, colors by Alex Sinclair.
RIGHT: The original cover by Joe Shuster for *Superman* volume one, #1 (June 1939).

THIS SPREAD: Lee's thumbnails for the entire oversized, 28-page *Superman* #204 (June 2004), the issue that began *For Tomorrow*. The page of thumbnails opposite top left later became the opening three pages to *Superman* #205 (July 2004). Pencils on paper.
OPPOSITE TOP RIGHT AND ABOVE TOP RIGHT: The final art for page two and page 18, respectively, of that same issue. Inks by Scott Williams, colors by Alex Sinclair.
LEFT: The final art for page 28 of *Superman* #204 (June 2004). Inks by Scott Williams, colors by Alex Sinclair.

113

The spectacular spread that appeared on pages 16 and 17 of *Superman* #204 (June 2004). Inks by Scott Williams, colors by Alex Sinclair.

ABOVE: Four rough proposals for the cover of *Superman* #205 (July 2004), done in pencils, inks, and markers on paper. "I'll do a very quick pencil sketch, and sometimes I'll ink that in, just so that the editors can more clearly see what I'm going towards. And then I'll really refine it on the actual drawing. I don't fuss too much with it in the sketch stage. The sketch stage, to me, is for approval. It's for the basic gist of the idea, so that people know that this character's in the middle and the character's doing this, and these characters are in the background and they're doing this. And when you draw it, you may refine movement of the arms, hands—that kind of thing."
BELOW: The final cover art for *Superman* #205 (July 2004). Inks by Scott Williams, colors by Alex Sinclair.
OPPOSITE: Detail of Lee's pencils for that same image. Pencils on art board.

SPLATTER INK AS WATER SPRAY ON OVERLAY GOING "↑" WAY

CLOUDY SKY

OPPOSITE: Lee's finished pencils for page 17 of *Superman* #208 (October 2004). Pencils on art board.

THIS PAGE: The finished art for that same page, which highlights some of the ways colorist Alex Sinclair contributes to both the visual impact and the narrative thrust of the art.

"It's really hard to screw up coloring Jim Lee because he's such a great artist. And Scott [Williams] comes through with such awesome inks over his stuff that it's really all there for you. One of the cool things, also, about working with Jim Lee is that he lets me push things when I want to. There are some artists who are really picky about their line art—'Don't mess with the line art!' Jim's more of a, 'Hey, if you can make it better, if you can improve it, if you can add to the mood or add to the storytelling, just go for it!'

"So he pretty much lets me do what I need to do, or what I think will work best. And that, I think, above anything else, is what makes working with Jim a lot of fun."

Inks by Scott Williams, colors by Alex Sinclair.

RIGHT: "With most projects I take a secondary role to the storyline, you know? To the extent that if [the writers] want feedback from me, I'll offer it. So I think where I have the most impact is in the initial discussions, where we sit down and talk about the character, the things we like about the character, and the stories that meant the most to us as fans growing up. I think a lot of that, even if it doesn't stick in an overt way, it kind of sits in the back of the writer's mind and spins around and, as they write the words and craft the stories, those discussions flavor or help direct the tone and focus of the stories that are crafted.

"And then I think that, when you're drawing the stories and the writer's getting visual feedback on the beats that he's trying to create for the story, they can tend to inspire or help direct, in a very nonverbal way, the future of the story as he writes additional, subsequent issues."
An early design for the *For Tomorrow* run. Pencils, inks, markers, and Wite-Out on paper.
BELOW: A detail of the finished art for page 19 of *Superman* #209 (November 2004). Inks by Scott Williams, colors by Alex Sinclair.

ABOVE: The purposefully brutal cybernetic supersoldier known as Equus attacks the Man of Steel in this final panel from page 14 of *Superman* #207 (September 2004). Pencils on art board.

Brian Azzarello's *For Tomorrow* script purposefully explored the gray areas of the DC Universe, and questioned Superman's place and purpose in a world in which one man's freedom fighter is another man's terrorist. It was an approach that set long-time allies one against the other, and challenged many of the core, accepted truths surrounding the central character.

BELOW: Jim's sense of humor is evident in the notes he's added to this pair of panels from pages two and 12, respectively, of *Superman* #208 (October 2004). Pencils on art board.

This blend of pencils and finished cover art for *Superman* #211 (January 2005) helps highlight the contributions inker Scott Williams makes to the final product. "On the best jobs that I've done with Jim, I feel like I'm bringing something to it. But I say that with the condition that you've got to look at it and, if you like it, it's because Jim and [the writer] have given me a really great platform to work from. And whatever I can add to it, that's great. I appreciate the freedom that they allow me, but it definitely is a collaboration." Inks by Scott Williams, colors by Alex Sinclair.

The cover of *Superman* #212 (February 2005). Pencils and inks on art board.
INSET: The final art for that same issue. Colors by Alex Sinclair.

LEFT: The cover of *Superman* #204 (June 2004) provided the template for the design of DC Direct's *Superman: For Tomorrow* statue. Inks by Scott Williams, colors by Alex Sinclair.

ABOVE: The *For Tomorrow* statue (November 2004) sculpted by Tim Bruckner, based on Jim Lee's designs. The run was limited to 6,500.

The penciled and inked art for the cover of the *Superman: For Tomorrow Volume One* hard- and softcover collections (April 2005 and May 2006, respectively). Pencils and inks on art board. Inks by Scott Williams.

BELOW: The finished art based on the same image. The "S" typically seen on Superman's chest is absent because it was replaced with a foil embossed emblem on the books. Inks by Scott Williams, colors by Alex Sinclair.

SUPERGIRL

SUPERGIRL, or Kara Zor-El, first appeared in *Action Comics* #252 (May 1959), written by by Otto Binder and illustrated by Al Plastino. She was originally conceived as the cousin of Superman, and on Earth acquired superpowers identical to Superman's (along with his vulnerability to kryptonite) and adopted the secret identity of Linda Lee. Supergirl subsequently went through various incarnations, with the "Supergirl" mantle being taken up by several different characters. The modern Kara Zor-El version of Supergirl was reintroduced into DC Comics continuity in *Superman/Batman* #8, titled "The Supergirl from Krypton" (2004).

RIGHT: "There are those who feel that Superman should be the only surviving Son of Krypton. But I know that for me, the charm of those Superman comics I grew up with was partly due to the idea that there had been many survivors," Lee reveals. "And Supergirl always worked best for me simply because she was his cousin.
"I think in an attempt to make the DC Universe more contemporary or coherent, sometimes creators would change some of the things that made these characters charming. So, when I do my take on them, I always mix a blend of the old with the new. That's what works best for me on a creative level."
That mixture of the tried and true combined with the freshly-minted is fully evident in this detail of a pin-up featuring Supergirl. Pencils, inks, and Wite-Out on art board.
BELOW: Even though it's just a rough sketch, this image wholly captures the grace and power possessed by Superman's youthful relative. Pencils on art board.

The Maid of Might enjoys a stroll amongst the clouds.
Pencils, inks, and watercolors on watercolor paper.

The dramatic final page of *Superman* #210 (December 2004). Inks by Scott Williams, colors by Alex Sinclair.

ABOVE: Wonder Woman is, at heart, as much a warrior as she is an ambassador of peace—a fact that even the Man of Steel forgets at his own peril, as is proved in this panel from page 12 of *Superman* #211 (January 2005). Inks by Scott Williams, colors by Alex Sinclair.

BELOW: This sketch highlights yet another weapon in the Amazonian Princess's arsenal—her unbreakable lasso of truth. Pencils, inks, and markers on art board.

WONDER WOMAN

SHE is the third of the trinity that includes Superman and Batman, and many consider her the most fascinating of the super heroes.

Sculpted by her mother Hippolyta from the clay of the island Themyscira, she was born into a tribe of Amazons, those incredibly skilled female warriors who fill their lives with art and beauty. A demigoddess possessed of superhuman abilities, she journeyed to the outside world to foster peace, love, and equality—and proved herself willing to support the value of those eternal truths by force, if necessary.

She was created by Dr. William Moulton Marston, a psychologist who crafted her from the stuff of legends and gave her vibrant life by virtue of his esteem for women. In the years since her 1941 debut, her adventures in comics and live-action and animated television shows have captivated women and men of all ages, inspiring them to strive for a better world.

Her name is Wonder Woman, and she is a daunting paradox.

"To work on the *Wonder Woman* series, I think I'd want to change a lot and add a lot," Jim Lee revealed. "Part of it, honestly, is that comic books are such a male-oriented industry.

"Also, the original Wonder Woman, as empowering a character as she is… it's not that her story doesn't fit in our time, but it's something that I think you'd have to adapt for the modern era. So in my mind, creatively, it's still kind of a work in progress."

OPPOSITE: When it comes to Wonder Woman, frequently the accessories are added late in the process. "I always draw that stuff last. To me, the lasso is an abstract element that you overlay on a more static mood shot, and it kind of adds some visual vibrancy to it. So I'll typically draw her knowing that she's going to hold the lasso. I'll draw her figure first, and then I'll take the pencil and—very, very quickly—draw the lasso shape. I have to do it quickly, so that I don't really think about it, otherwise it won't look as spontaneous and as dynamic as it could be." Pencils and inks on art board.

THIS PAGE: Another work-in-progress portrait of DC's leading female character, this one in pencils, inks, ink wash, markers, and Wite-Out on art board.

ABOVE: Diana's parting glance toward the friend she's just fought, from page 21 of *Superman* #211 (January 2005). Inks by Scott Williams, colors by Alex Sinclair.
BELOW LEFT: Sketch done as a birthday gift for inker (and artist) Sandra Hope. "I love what she brings to the pencils I give her. The *Infinite Crisis* covers really turned out nice simply because she is a perfectionist and gives you her best each and every time." Pencils and inks on art board (2005).
BELOW RIGHT: Sketch for a fan, portraying one of the many moods of Wonder Woman. Pencils and inks on art board.
OPPOSITE: Princess Diana stands before the hallowed halls of Themyscira with two of her protégés, Donna Troy and Cassandra Sandsmark. Pencils, inks, and Wite-Out on art board (2007).

ABOVE: A panel from page six of *All Star Batman & Robin, The Boy Wonder* #5 (July 2007). Inks by Scott Williams, colors by Alex Sinclair.
BELOW: Pencils for the first two panels for that same issue. Pencils on art board.

The opening splash page from *All Star Batman & Robin*. Inks by Scott Williams, colors by Alex Sinclair. "It's definitely a harder-edged version of these characters than previously seen. But, in Frank's universe, these characters *know* that they are iconic, that they are mythological, but at the same time there's an attendant… what's the word I'm looking for? Not disgust. That would be too strong a word. But a sense that, if you were one of these near-godlike characters, some of whom are immortal, what kind of attitude and outlook would you have on modern society—especially if you're fighting crime? What kind of attitude would you have towards humanity?"

JUST IMAGINE STAN LEE'S WONDER WOMAN

FOR Jim, working on the *Just Imagine Stan Lee with Jim Lee Creating Wonder Woman* project "was amazing. I've known Stan for years, ever since I started at Marvel. In many ways he's my role model/mentor, and has always been the nicest guy to me. He's great company, a really amazing creator, and the first time he's doing something big for DC, I get to be involved.

"What was interesting is that he looked at all the DC characters and completely made them his own. He didn't do anything that really suggested or spoke of the original DC characters, except perhaps with Batman. But with Wonder Woman, he did something very different and contemporary, and it was just great to collaborate with him. And we worked Marvel style, which was really thrilling. So, that definitely will remain one of the highlights of my career."

Stan Lee was equally enthusiastic about working with Jim on the project. "He's the nicest guy in the whole world, and there is no better artist than Jim Lee. What a joy he was to work with."

BELOW: Three of Jim's rough cover layouts for the one-shot. Pencils, inks, and markers on paper.

ABOVE: On working with Jim, Stan Lee observed, "A lot of people can draw beautifully. But to do a good comic strip or graphic novel, you've also got to be able to tell a story well. It's not just a series of drawings within panels, but the drawings have to flow in a certain way.... Jim is one of a handful of artists who not only is a magnificent artist, but he tells a story beautifully with his artwork, and that's so important."

Two of Jim's designs for the titular lead character. Pencils, inks, and markers on paper.

The final cover art for the *Just Imagine Stan Lee with Jim Lee Creating Wonder Woman* one-shot (October 2001), *sans* logo and other overlays. Inks by Scott Williams, colors by Alex Sinclair.

Composite image of the inked and raw pencil versions of the covers for, left to right, *Trinity* issues 32 and 33 (January 7 and 14, 2008). Pencils and inks on art board; pencils on art board.

TRINITY

A special weekly series that focused on DC Comics' "big three" characters, *Trinity* featured covers by some of the industry's top talent.

A

B

ABOVE AND BELOW: Two of Lee's rough proposals for the triptych creating the covers for *Trinity* issues 25 through 27. Pencils, inks, and markers on paper.

ABOVE TOP RIGHT: The final art of this triptych image was broken into three parts to create, from left to right, the covers of issues 25, 26, and 27 of *Trinity* (November 19 and 26, and December 3, 2008), featuring the characters Morgaine Le Fey, Enigma, and Konvikt. Inks by Scott Williams, colors by Alex Sinclair.

ABOVE RIGHT: The final art for the triptych image that created the covers for, left to right, *Trinity* issues 13 through 15 (August 27, and September 3 and 10, 2008). DC's trinity are fighting Superwoman, Owlman, and Ultraman—villainous versions of themselves from an alternate Earth. Inks by Scott Williams, colors by Alex Sinclair.

ABOVE: This triptych was broken into three parts to create the covers of, from left to right, *Trinity* issues 16, 17, and 18 (September 17 and 24, and October 1, 2008). Inks by Scott Williams, colors by Alex Sinclair.

THIS IMAGE: Lee's pencils of the covers for, from left to right, *Trinity* issues 13, 14, and 15 (August 27, and September 3 and 10, 2008). Pencils on art board.

DC HEROES

ABOVE: The members of the Justice League of America, past and present, gathered together (along with some of the Justice Society). Since they first appeared in *The Brave and the Bold* #28 (February-March 1960), the Justice League—like their Golden Age predecessors the Justice Society—have boasted a roster encompassing all of the major heroes of the DC Universe. Detail of page 16 from *Justice League of America* volume two, #0 (September 2006). Inks by Scott Williams, colors by Alex Sinclair.
RIGHT: Lee's sketch of the Flash, a founding member of the JLA and the Fastest Man Alive. Pencils, inks, ink wash, markers, and Wite-Out on art board.
OPPOSITE: This 2010 image, created to welcome DC Entertainment's new president, Diane Nelson, into the fold, touches upon an aspect of Jim's work that he feels needs more attention. "I drew a piece of the Justice League sort of bursting forth with the Tiny Titans around them, and all the characters are either smiling or looking sort of emotionally neutral, and it was different. It had a very different feel, because in so much of the stuff I do, the characters look very stern, and I've had a lot of people say they always look angry. And they never looked angry to me before, because I was so used to drawing them that way. But now, looking back at it with some perspective, I go, 'Wow, I *do* tend to draw these characters looking fairly pissed off!'
"That definitely touches a large chunk of the core audience, the older teenagers and young adults, but having the characters smile and be more civilian-friendly is something that probably has broader appeal to younger kids and older fans who aren't necessarily into the core comic books. So I actually want to do more of those kinds of pieces." Inks by Scott Williams, colors by Alex Sinclair.

LEFT: Green Lantern Kyle Rayner floating in the void. Pencils, inks, watercolors, and Wite-Out on art board (2002).
BOTTOM LEFT: Lee's turnaround design for Kyle Rayner. Pencils and inks on art board.
BELOW: Two profiles of Rayner. Pencils and inks on paper. Pencils on art board.
BOTTOM: Full figure sketch of Rayner, modeling another costume design by Jim. Pencils, inks, and markers on art board.

LEFT: Hal Jordan, the original Silver Age Green Lantern. Pencils, inks, and Wite-Out on art board.
BELOW LEFT: John Stewart, another member of the Green Lantern Corps. Pencils, inks, and Wite-Out on art board.
THIS IMAGE: Detail from Jim's pencil art for the variant cover of *Green Lantern* volume four, #50 (January 2010).

ABOVE: Suspense novelist Brad Meltzer asked Jim to update the Watchtower for his acclaimed run on *Justice League of America*, complete with two tiny defensive satellite drones around the lower half. After the initial shape was chosen (on the left), Jim tied the final look of the floating headquarters to the already familiar one on Earth. Pencils on paper (2007).
BELOW LEFT: Rough headgear and footgear designs for Hawkman's costume. Markers on lined paper.

RIGHT: "The Hawkman sketch is one I did just for fun in pencils. Normally, I ink my sketchwork, but this time I wanted to keep it rough so I could play with the shadows and tones more. I'm a huge fan of the Thanagarian hero and wanted to draw a costume which looked a bit updated while staying true to the original, classic design." Pencils on art board.
FAR RIGHT: "Plas was a special order done for *Wizard* magazine #176 because they wanted to preview what my version of the Justice League would look like, and I had drawn all the characters before except for Plastic Man. Alas, he was cropped very tightly, spoiling the physical shtick." Pencils and inks on art board (June 2006).

Jim's rendition of two perennially popular characters, Green Lantern and Green Arrow. Pencils, inks, ink wash, markers, and Wite-Out on art board.

FOR MIKEY! IN APPRECIATION! BEST JIM LEE

INFINITE CRISIS

LEFT: These three versions of the same cover design for *Countdown to Infinite Crisis* offer real insight into how Lee works out which lighting effect will have the most impact. "Sometimes, if I'm pencilling a page or a cover, if I'm not quite sure how the blacks are going to look, I'll make photocopies of the image before the blacks are spotted in. And then I'll take a Sharpie or a brush and actually fill in black shapes, and do it differently on each photocopy to see how far I should go in terms of spotting blacks, and what areas would look best if they were made black. But, after a while, you get a sort of instinctive feel for it, and you do it by feel." Pencils and markers on paper.

OPPOSITE RIGHT: The final cover for *Countdown to Infinite Crisis* #1 (May 2005), drawn by Jim Lee and painted by Alex Ross. Lee did variant covers for all of the issues in this mini-series. In the first printing, Blue Beetle was grayed out on the cover in order to keep the issue's cliffhanger ending under wraps.
BELOW: Detail of the inks for the cover of *Infinite Crisis* #3. Pencils and inks on art board. Inks by Sandra Hope.
RIGHT: Top to bottom, the rough layouts, finished pencils, and final cover art for *Infinite Crisis* #2 (January 2006). Inks by Sandra Hope, colors by Alex Sinclair.

INSET BELOW: Lee's rough cover designs for *Infinite Crisis* #6 (May 2006). Pencils and markers on paper.
INSET BOTTOM: The finished pencils of that same cover. Pencils on board.
RIGHT: The final cover art of *Infinite Crisis* #6.
OPPOSITE: Jim went all-out when creating this vertigo-inducing image for the cover of the seventh and final issue of the *Infinite Crisis* miniseries (June 2006). Pencils on board.
NEXT SPREAD: Final cover art for *Infinite Crisis* #7. Inks by Sandra Hope, colors by Alex Sinclair.

WILDSTORM

WILDSTORM Productions was established by Jim Lee after he helped found Image Comics in 1992. Its first release was the wildly popular *WildC.A.T.s* title, which served to define the broad outlines of the company's self-contained WildStorm Universe, where warring alien races and super heroes are a natural part of the world.

Various other series set in the same universe were added as time passed, including *StormWatch*, *Deathblow*, *Gen¹³*, *DV8*, and *The Authority*. The company has also released a variety of licensed comics, as well as creator-owned comics like *Kurt Busiek's Astro City* and *Danger Girl*, under its Homage and Cliffhanger Comics sub-imprints. And its America's Best Comics imprint is an entire line of super heroes created by Alan Moore and others.

WildStorm itself was essentially an outgrowth of Homage Studios, a collective Lee formed in San Diego, California, several years earlier.

"Well, even before we started Image, I had set up a small studio called Homage. We had a one-bedroom apartment, and then a two-bedroom apartment, that Scott Williams, Whilce Portacio, Joe Chiodo, and I worked out of. There was also an assistant who helped everyone take care of whatever came up, so we had *some* infrastructure—and we had a fax machine.

"So, when Image started, we expanded this small kernel of a studio and found some commercial space, because we knew we needed more room to grow. Letterer Mike Heisler wanted to be involved, so he moved out here. Colorist Joe Rosas and a bunch of people came out, and fellow Image partner Marc Silvestri moved down from LA. We rented out four thousand square feet, and we learned by doing. We were always fond of saying, 'We did *everything* wrong, and we still survived!' And I think we really learned just by doing things as they came along.

"We didn't plan too much at the start because it was just moving so damn fast."

That explosive growth lead to WildStorm's series of talent searches, resulting in the discovery of a variety of new artists including J. Scott Campbell, Travis Charest, and Lee Bermejo, creators who have since become established figures in the industry.

"I'm very proud of the fact that we brought in a lot of guys from all around the country—from around the world, actually—and that we passed along knowledge and skills which we had never been formally given ourselves when we were their age. So there were definitely good things that came out of Image Comics, and that would rank up there as one of the best."

However, that same rapid expansion had a real and profound effect on Lee's ability to produce his own creative work. "I'd go up to LA, drive three and a half hours for a meeting, and drive back three and a half hours, and then sit down and try to draw a page. It just doesn't happen. You're just exhausted."

That situation, compounded by increasingly soft sales in the comics, cards, and related markets, took an increasingly heavy toll on Lee, leading to his decision to accept DC's offer to buy the company in 1998.

He rededicated himself to creating new stories and art, even as he served DC Comics as an executive vice president and editorial director, in charge of WildStorm's operations. During that same period, WildStorm has flourished under the new ownership, expanding the number and diversity of its offerings while encouraging its creators to further expand the medium's limits.

In February 2010, Lee was named co-publisher of DC Comics, alongside former senior vice president and executive editor Dan DiDio. In essence, this transformed the WildStorm Productions offices located in La Jolla, California, into the west coast headquarters of DC Comics.

OPPOSITE: The finished art for the variant cover of *Wildcats* volume two, #8 (April 2000). This was the left half of a cover that connected with a variant cover for *Gen¹³* #50. This issue marked a new creative team for *Wildcats*, featuring Joe Casey and Sean Phillips. Inks by Scott Williams, colors by Laura Martin.
TOP: Early designs for two members of the villainous WarGuard—Nychus and Talos. Pencils on paper.
ABOVE: WildStorm Productions' 1993 Christmas card, featuring Jacob Marlowe, Voodoo, and a frosty version of Grifter. Pencils and inks on art board.

WILDC.A.T.S

CREATED by Jim Lee and Brandon Choi, the WildC.A.T.s (Covert Action Team) are comprised of mutated humans and the humanoid survivors and half-breed descendents of the crew of a Kheran spacecraft which, along with an opposing ship piloted by the enemy Daemonites, crashed on Earth thousands of years ago. Their battle has continued down through the ages to this day, as evidenced in humanity's myths and legends.

PREVIOUS SPREAD, CLOCKWISE FROM LEFT: Cover art for the first issue of *WildC.A.T.s* volume one (August 1992). Inks by Scott Williams, colors by Alex Sinclair.
This image of Grifter was the cover to the *Jim Lee Sketchbook* (2003). Pencils on paper.
"With the best costumes these days, less is more." Warblade redesign (2006). Pencils on art board. Colors by Scott Iwahashi.
The team answers the call to arms on page three of *Wildcats* volume four, issue #1 (December 2006).
ABOVE: Lee's pencils for the cover of *Wildcats* volume four, #1 (December 2006). Pencils on art board.
RIGHT: That same cover, fully inked by Scott Williams.

ABOVE: An early sketch of Grifter. Pencils, inks, and markers on art board.
RIGHT: An image of the character from 2005. Pencils, inks, and ink wash on art board.
OPPOSITE: The inked art for the cover of *Grifter: One Shot* (January 1995). Pencils and inks on art board.

160

> MOVE IT, ZEALOT! WE GOTTA GET THROUGH *THOSE DOORS* BEFORE THEY SEAL OFF THIS AREA!

> THE DROIDS ARE *TOO CLOSE.*

> YOU GO ON AHEAD WHILE I SLOW THEM DOWN.

TOP: Grifter and Zealot discuss strategy in the thick of battle in the last panel on page nine of *WildC.A.T.s* volume one, #5 (November 1993). Inks by Scott Williams, colors by Joe Chiodo.
ABOVE: Head studies of Zealot for the *WildC.A.T.s* animated cartoon on CBS. Pencils on paper.
RIGHT: Portrait of Zealot, dressed to kill, from 2006. Pencils, inks and markers on art board.
OPPOSITE: "This was an obvious homage to an earlier cover I did for the new *X-Men* title I was working on before I launched *WildC.A.T.s.* That cover, coincidentally, was also for issue four." Cover for *WildC.A.T.s* volume one, #4. Inks by Scott Williams, colors by Alex Sinclair.

Originally an exotic dancer, Voodoo strikes a sultry pose in this rare moment. Pencils, inks, ink wash, and Wite-Out on art board (2007).

RIGHT: Zealot holds her ground before an onslaught of Daemonites in an exclusive WildStorm print from 1995. Colors by Alex Sinclair.

BELOW RIGHT: Jim drew this life-size Grifter on the office wall of former WildStorm general manager John Nee, where current general manager Hank Kanalz enjoys seeing it on a regular basis (2000). Pencils, inks, and Wite-Out.

OPPOSITE: Zealot print exclusively sold through WildStorm (1995). Pencils and inks on art board.

TOP: More head and face studies for the *WildC.A.T.s* CBS cartoon. From left to right, Void and Grifter, Warblade, and Lord Emp, otherwise known as Jacob Marlowe. Pencils on paper.
ABOVE: More facial expressions studies—in this case for Maul. Pencils on art paper.
RIGHT: Lee's 2005 concept design for Maul, the human-Kherubim hybrid with the ability to increase his mass… at a cost. Pencils on art board.

STRAFE
© 1992 JIM LEE

GRIFTER © 92 JIM LEE

ZEALOT © 92 JIM LEE

CODA ASSASSIN JIM LEE © 92 1·5·92

CADRE OF CODA ASSASSINS ARE ALL FEMALE A LA AMAZONS; NATURALLY THEY'RE ~~A~~ MYSTERIOUS AND DEADLY—CAN ALSO MANIPULATE MEN...

CLOCKWISE FROM TOP LEFT: An unused character who was only seen in one promotional image for the series (1992). Pencils and inks on art board.
Early character designs for Zealot and Grifter (1992). Pencils and inks on art board.
An early male Coda assassin (1992). Pencils and inks on art board.
Rare, never-before-seen sketch of a Coda assassin (1992). Pencils and inks on art board.

ABOVE: Detail of the inked art for the cover of *WildC.A.T.s* volume one, #8 (February 1994). "I wanted to do a different type of cover here. Something more playful and fun. Action on covers is always a draw, but sometimes going against the flow is what gets a cover noticed." Pencils and inks on art board.

BELOW LEFT: Jim's color design for the voluptuous Voodoo, from 2006. Pencils, inks, and markers on art board.

BELOW RIGHT: The many moods of Voodoo. Studies for the *WildC.A.T.s* cartoon. Pencils on paper.

Voodoo, showing an entirely different side of herself. Pencils, inks, and watercolors on paper.

OPPOSITE: Building a better robot. Panel one from page nine of *WildCats*, volume four, #1 (December 2006). Pencils on art board.
ABOVE: Panels two through five from that same page and issue of *WildCats*. Pencils on paper.
BELOW: Panels three through five of page nine from *WildCats* volume four, #1. The content and themes of the series matured along with the characters, offering rich opportunities for the creators to explore new territory. Inks by Scott Williams, colors by Alex Sinclair.

ABOVE LEFT: To mark the start of Alan Moore's epic 14-issue run, Jim contributed the cover to *WildC.A.T.s* volume one, #21 (July 1995). Moore not only introduced fan-favorites TAO and Ladytron, but revisited the Kherubim and Daemonite war while splitting the team into two simultaneous storylines. Inks by Troy Hubbs, colors by Homer Reyes.
ABOVE RIGHT: Jim returned to the interior of the series with *WildC.A.T.s* volume one, #31 (September 1996). On the cover he caught the team off-duty before the action heated up inside. Inks by Richard Bennett, colors by WildStorm FX.
BELOW: Jim's rough cover layouts for *Wizard* magazine #180 (October 2006), celebrating Jim's return to WildStorm's flagship title. Pencils, inks, and markers on paper.

The finished pencil illustration for that *Wizard* cover.
Pencils on art board.

WILDCATS TRADING CARDS 13 14

OPPOSITE: This 1993 *WildC.A.T.s* image first appeared in *Inside Image* (a promotional magazine for the imprint) and was later re-used as the cover for the Super Nintendo *WildC.A.T.s* game. Inks by Scott Wiliams, colors by Alex Sinclair.
ABOVE: Inked art for what became cards D1 to D6 in the *WildC.A.T.s* '94 set, the first oversized, all chromium trading card set ever. Pencils and inks on art board.
NEXT SPREAD: The wraparound cover to *WildC.A.T.s* volume one, #50 (June 1998). "This is an oddity, in that I believe the costumes here only appear on this cover. I like Zealot and Voodoo's looks, so they may surface again someday." Inks by Scott WIlliams, colors by Ben Dimagmaliw.

GEN¹³

THE members of the Gen¹³ team are escapees from a covert government lab where teens who all carry a mutated genetic strain, granting them superhuman abilities when they reach a certain age, were held against their will and experimented upon. The original team consisted of Caitlin Fairchild, Roxanne "Freefall" Spaulding, Percival Edmund "Grunge" Chang, Sarah Rainmaker, and Bobby "Burnout" Lane, with their mentor, John Lynch. Created by Jim Lee, Brandon Choi, and J. Scott Campbell, Gen¹³ spawned two spinoff books, *DV8* and *Gen¹³ Bootleg*. The series has undergone several revamps and "reboots," including blowing up the entire team with a six megaton bomb in issue 76 (July 2002).

OPPOSITE: Jim freely admits that he himself loves to perform a variety of experiments, as demonstrated by this cover to *Gen¹³* volume three, #0 (September 2002). "I always like mixing up the medium… employing kind of an atypical art style where I pencil using photo reference, scan the illustration into a computer, overlay it on a watercolor paper scan, and then create Wite-Out effects on it in Photoshop, right onto the file itself. The original art is on regular traditional white paper, but the final outputted file looks like it was drawn and inked and colored using Wite-Out on gray watercolor board." This issue only cost 13 cents, and tied into the WildStorm series *21 Down* and *Resistance*.

ABOVE: Caitlin Fairchild, the super strong member of the team, from page one of *Gen¹³* volume two, #7 (January 1996). Inks by Scott Williams, colors by Joe Chiodo.

LEFT: Jim's rough layout for the cover of *Gen¹³* volume one, #2 (March 1994). Pencils and inks on art board.

ABOVE: Final art for the cover of Gen¹³: European Vacation Collector's Edition #1 (August 1997). Colors by Alex Sinclair.
BELOW LEFT: Early designs for the core members of the team. Pencils on art board.
BELOW RIGHT: Black and white character studies of the various members of the team. Pencils, inks, and markers on art board.

ABOVE: An evocative—and provocative—portrait of Caitlin done in pencils, inks, markers, and watercolors on art board. This "was done in half an hour using a tech pen and watercolors."
RIGHT: Detail from the cover of *Gen¹³* volume two, #1/2 (March 1994). Inks by Alex Garner, colors by Alex Sinclair.
BELOW: A full-color sketch of Caitlin, transformed into a 'toon version of herself. Pencils, inks, markers, and watercolors on art board.

ABOVE LEFT: Jim's pencils for the cover of Gen¹³ volume two, #6 (November 1995). Pencils on art board.
ABOVE RIGHT: The final cover for that same issue, including the book's distinctive logo. Inks by Scott Williams, colors by Rob Ro.
BELOW: Detail of a pin-up from #64, featuring the villains Threshold and Bliss. Colors by WildStorm FX.
OPPOSITE: The cover to Gen¹³ volume two, #7 (January 1996). "Done as an homage to J. Scott Campbell's cover to Gen¹³ #1, this was a fun cover to draw simply because I think the costume that Jeff designed for Sublime was just inspired. Still works for me today." Inks by Scott Williams, colors by Tad Ehrlich.

JIM LEE
WILLIAMS
AFTER
CAMPBELL

To Grunge I ♥ Love Miss Fuli xxoo

This captivating image of Miss July is from the *Gen13 Yearbook 1997* (June 1997). Inks by Richard Bennett, colors by WildStorm FX.

DV8

DV8 is, in many ways, the dark reflection of Gen[13]. Comprised of teens with a variety of superpowers, the team members fought with each other and the forces of apathy, self-destruction, and basic morality in the 32-issue original series. A new volume saw print in the summer of 2010 from writer Brian Woods and artist Rebekah Isaacs. Frostbite is indulging in a little time off here as one of the seven deadly sins in this variant cover to #1 (September 1996). Pencils and inks on art board. Inks by JD.

Jim Lee contributed this cover to Brian Wood and Rebekah Isaacs's re-envisioning of the team in *DV8: Gods and Monsters* #1 (June 2010). Inks by Scott Williams, colors by Alex Sinclair.

SHOOT 'EM
ALL
LET GOD
SORT 'EM OUT

OPPOSITE: The cover to the European Edition of *Divine Right* #1 (September 1997), featuring Christy Blaze with Brande and Tobruk, two of the Fallen. Colors by WildStorm FX.
RIGHT: The cover of *Divine Right* #1 (September 1997). Colors by WildStorm FX.
THIS IMAGE: Max gets his godhead on in the original solicitation cover for *Divine Right* #6 (1998). Inks on art board.

DIVINE RIGHT

DIVINE *Right: The Adventures of Max Faraday* was a 12-issue miniseries created by Jim Lee which answered the question, "What happens when a twenty-something dedicated slacker and pizza delivery boy is granted God-like power over reality?" It also marked the first time that Lee wrote and penciled a title by himself.

"One thing about writing is that it's not something you can necessarily take a break from. With art, if you want to take a break, you step up, walk away, and go out for a drive. You're not working, you're taking time off. With writing, with the way I tend to analyze everything anyway, I think I just would never stop thinking about it, and it would be draining. In fact, when I did write and draw *Max Faraday*, it was a grueling experience because I would finish the artwork, and normally that's when you sort of let yourself down emotionally, let yourself down physically. But I would have to immediately turn around and provide the script. And then, after that, review the lettering. And, after that, review the coloring. And it was just never-ending. You were always working, always on. Neverending deadlines were rough."

The inked art for page one of *Divine Right* #1 (September 1997). Pencils and inks on art board.

THIS PAGE: Detail from the finished art for the cover of *Divine Right* #11 (November 1999). Colors by WildStorm FX.
ABOVE: Max and his allies gather on pages three and four from *Divine Right* #4 (December 1997). Colors by Joe Chiodo and Martin Jimenez with WildStorm FX.

OPPOSITE: Inked art for the *Divine Right* collected edition #1 (January 1998). Pencils and inks on art board.
ABOVE LEFT: Max's sister, Jenny, and his brilliant but flawed best friend, Devan Lawless, face to face with the Rath, on the cover of *Divine Right* #6 (August 1998). Colors by Tad Ehrlich.
ABOVE TOP RIGHT: The inked art for the cover to the Pacific Comic Convention variant edition of *Divine Right* #5 (February 1998), featuring Exotica, Brande, and Max. Pencils and inks on art board.
ABOVE RIGHT: Finished art for the same image. Colors by Tad Ehrlich.

193

LEFT: Detail of the variant cover art for *Divine Right* #2 (October 1997), spotlighting Christie Blaze and Exotica (of the Fallen). Colors by Ben Dimagmaliw.
BELOW: Sketch portrait of the woman warrior known as Christy Blaze, produced for a 1998 convention promotion. Pencils on art board.
OPPOSITE: Final art for the American Entertainment variant cover of *Divine Right* #1 (September 1997). Inks by Scott Williams, colors by Alex Sinclair.

ABOVE LEFT: Cover art for *Divine Right* collected edition #2 (November 1998). Inks by Scott Williams, colors by Tad Ehrlich.
ABOVE RIGHT: Final art for the cover of *Divine Right* #4 (December 1997). Inks by Scott Williams, colors by Tad Ehrlich.
BELOW: "And they lived happily ever after…" Max and his girlfriend, Susanna Chaste, experience an (unfortunately only imaginary) happy ending at the end of issue 9 (July 1999). Colors by Tad Ehrlich and WildStorm FX.
OPPOSITE: Inked promotional art featuring Acheron. Pencils and inks on art board.

LEFT: The Max Faraday inked figure in the foreground, and the penciled headshots of, left-to-right, Spartan, Grifter, and Zealot in the background—that form the basis for the cover of the collected volume *Divine Right: The Adventures of Max Faraday* book two (November 2002). Pencils and inks on board. Inks by Richard Friend.

THIS IMAGE: Jim's finished art for the background headshots, with the Faraday figure ghosted in the foreground. Pencils, inks, ink wash, markers, watercolors, and Wite-Out on art board.

BELOW LEFT: The colored Max Faraday figure, against a colored background. Colors by Alex Sinclair.

BELOW: Computer composite of the finished foreground and background images.

The dramatic result when all of the elements are brought together to form a finished piece, with extra computer coloring and effects.

While Deathblow's earliest adventures provided Lee with a platform to explore the use of negative space—as this and other pieces demonstrate—the character's world came to include a wide spectrum of hues. Pencils, inks, ink wash, markers, watercolors, and Wite-Out on art board.

RIGHT: He is a killer with few equals, even in a world where blood is shed with less thought than one might draw a breath. His name is Deathblow, and now that he's facing the end of not just his life, but the apocalypse itself, he has an impossible mission—redemption, and saving the world from a demon who would devour it whole. And that's just the start of his story… Pencils, inks, ink wash, markers, watercolors, and Wite-Out on art board.

BELOW RIGHT: Michael Cray, a.k.a. Deathblow, doing what he does best on the cover of *Deathblow* volume one, #4 (April 1994). Colors by Alex Sinclair.

DEATHBLOW

DEATHBLOW was the brainchild of Jim Lee and Brandon Choi. The character first appeared in *Darker Image* #1 (August 1992), then continued in his own ongoing series of 30 issues, published by Image Comics (May 1993-August 1996), and later relaunched in 2006 as a WildStorm title. Inspired by Frank Miller's *Sin City*, it followed Michael Cray, an ex-Navy SEAL, who teamed up with a secret religious order to prepare for the upcoming battle with the Antichrist. Jim told this story of religion, fanaticism, salvation, and redemption in a totally new style that was more visceral and dramatic than his past work.

OPPOSITE: Cover art for *Deathblow* volume one, #0 (August 1996). Colors by WildStorm FX.
ABOVE RIGHT: Detail of the *Deathblow* volume one, #1 (April 1993) cover.
RIGHT: Final art for the alternate cover of *Deathblow* volume one, #28 (July 1996). Inks by Alex Garner, colors by Rob Ro.
ABOVE: An early concept design. Pencils and inks on art board.

Inked art for the cover of *Deathblow* volume one, #9 (October 1994). Pencils, inks, and Wite-Out on art board.

Cover to *Deathblow* volume one, #5 (May 1994). Colors by Alex Sinclair.
NEXT SPREAD: The wraparound cover art for *Deathblow* volume one, #11 (December 1994). Colors by Ben Dimagmaliw.

DEATHBLOW

STORMWATCH is another Jim Lee–Brandon Choi creation, the result of a partnership whose roots extend back to their childhood in St. Louis, and a period when they often spent hours after school making up their own comic characters.

Their first professional work together was published by Marvel Comics in the early 1990s when, at Lee's invitation, Choi became an uncredited co-creator of characters and plots during Jim's run on the new *X-Men* title. Their collaboration only grew stronger after Lee became a founding father of Image Comics, and they began laying the foundations of what would become the WildStorm universe. It seemed only natural that they would reach back to those long afternoons spent dreaming up their own characters, and make those characters part of their new world.

On this page you'll find some of the earliest drawings of the creations who, in altered guises, would later find life as members of the UN-sponsored superhuman peace-keeping strike-force known as StormWatch.
LEFT: An early version of Blademaster. Pencils and markers on paper.
BELOW: The group, variously known as The Enforcers, N-Force, and M-Force, that would later become StormWatch. Pencils and markers on paper.
OPPOSITE: Jim's pencils for the cover of *StormWatch* #2 (May 1993). Pencils on art board.

STORMWATCH

More character designs from the early days when Lee was developing the visual look of the WildStorm line. Clockwise from upper left: Battalion, Battalion in armor, Flashpoint, Nautika, Swift, Comanche, Prism, and Flint. The latter four first appeared in *StormWatch* volume one, #28. Pencils, inks, and markers on art board.
OPPOSITE: Page six of *StormWatch* #47 (May 1997). Every page of this issue was a splash page. Inks by Richard Bennett, colors by Gina Going.

OPPOSITE: Jim used mostly ballpoint pen to complete the cover of *Coup d'État: Sleeper* (April 2004), featuring the members of the Authority. Colors by Alex Sinclair.
BELOW: A sketch of the alien race known as the Vigil, who declare war on our universe in this storyline. Pencils on art board.

COUP D'ÉTAT

COUP *d'État* is a four-issue miniseries in which the US government is tricked into accidentally causing an interdimensional war. As a consequence, the superhuman group known as the Authority seizes control of the United States—an act which has a profound impact upon the entire WildStorm universe.

Apollo and Midnighter fly into action. Pencils on paper.
BELOW LEFT: Inked art for page 22 of *Coup d'État: The Authority* (April 2004).
BELOW RIGHT: Jenny Sparks of the Authority shares a pint with a friend. Pencils, inks, ink wash, markers, and Wite-Out on art board.

THE FILTHY MONKEY... IT PLANS

EYE OF THE STORM:
COUP D'ETAT #1

Note on the lettering – All narration in this issue should be done in the style of the narration in Sleeper. And for the telepathic stuff between the Authority members, let's go back to the classic blue outlined ovals with the typeset look, appeal to the old fans that might be trying the book again to see Jim draw the characters.

Credits will go at the end, on the last page, which is mostly a splash.

Jim -- I've decided against sound effects, because they never used them in the Authority when Warren Ellis wrote it. If you want to use them, though, just make up your own. They're best when they're actually part of the artwork instead of the lettering anyway, I think. Also, feel free to add panels as you tell the story, I'm trying to leave it pretty open for you. And don't feel the need to draw everything I describe, as I'm usually just trying to give you an good idea of everything you might need to know to make a scene work. You'll be able to tell easily what's important or not, I think.

PAGE ONE

1—A wide shot. A street is shrouded in flames. A car is burning, a husk more than a car, really. Palm trees are burning like match-sticks, black and ruined. An old man is lying on the sidewalk, his hand still gripping a dog leash, but he and the dog and burned to death, bones and melted flesh. He's wearing a flowered shirt, or what's left of one. This is a grisly scene.

 NARR: The storm hit Florida early that morning.

2—In the sky above the burning trees, a flaming skeleton of immense proportion, with the third eye in its forehead, is rocketing toward us, and there are others like it on the way, farther up in the sky, like little flaming raindrops or something, but with dark centers.

 NARR: Alien destruction raining down from on high...

 NARR: ...From another place altogether, another dimension... Seemingly without reason.

3—As the skeleton hits a building, we get an idea of how huge it is – it's almost as big as the skyscraper it's colliding with. The building explodes on the impact.

 NARR: But there's *always* a reason...

 NARR: ...You just have to know who to ask.

4—Pull back and we can see a lot more of these flaming projectiles hitting the world, buildings exploding, streets ripped in two, tiny human corpses flying through the air in the explosions.

 VOICE-OVER BOX: "Because they think they can save the world..."

Coup D'Etat #1 – final– pg. 1

OPPOSITE: *Coup d'État: Sleeper* #1 preview page originally published in *Wizard* magazine #147 (January 2004). Pencils and inks on art board.
ABOVE: Page one of the *Coup d'État: Sleeper* script by Ed Brubaker and the finished Jim Lee art for that same page. Colors by Alex Sinclair.
BELOW: Inked art for pages 10 and 11 of *Coup d'État: Sleeper* #1 (February 2004). Pencils and inks on art board.

CAPTAIN ATOM: ARMAGEDDON

BETWEEN 2005 and 2006, the character Captain Atom played a central role in a nine-issue DC-WildStorm inter-company crossover called *Captain Atom: Armageddon*. Hurled between dimensions by events in the DC Comics series *Superman/Batman*, Captain Atom finds himself in the WildStorm Universe. The series explored the differences between the two universes, ultimately tying them more closely together, while also creatively "rebooting" the WildStorm Universe, allowing new creators to start fresh with all-new stories and directions.

The variant cover for *Captain Atom: Armageddon* #1 (December 2005). Inks by Scott Williams, colors by Alex Sinclair.

OPPOSITE: Deathblow, Caitlin Fairchild, and Grifter shown in Lee's finished pencils for page 22 of the ninth and final issue of the *Captain Atom: Armageddon* limited series (August 2006). Pencils on art board.

EX MACHINA

CREATED by Brian K. Vaughan and Tony Harris, *Ex Machina* stars Mitchell Hundred, a former super hero who has become a politician. Weaving in realistic politics with flashbacks to super-hero action, *Ex Machina* showcases the metaphoric power of super heroes and comics as a whole.

THIS SPREAD: A mix of pencils and final art is shown here for a two-page sequence from pages 21 and 22 of *Ex Machina* #40 (February 2009), which showed what the series might have looked like if it had been written by Garth Ennis with art by Jim Lee. Inks by Richard Friend, colors by JD Mettler. *Ex Machina* ™ and © 2010 Brian K. Vaughan and Tony Harris.

THE INTIMATES

A 12-issue miniseries from writer Joe Casey, with art by Giuseppe Camuncoli and Jim Lee, *The Intimates* focused on the lives of five teens possessed of odd but surprisingly effective superpowers. They attend a school for superhumans called the Seminary, with a curriculum that includes Secret Identity 101. The series pushed the limits of the comics medium even as it downplayed the superpowered heroics, choosing instead to concentrate on the characters' personal lives and interactions. "This is the first project I've co-created since WildStorm became a part of DC. It's been really fun to flex those muscles again."

BELOW: The cover to *The Intimates* #4 (April 2005). Design by Rian Hughes, colors by Randy Mayor.
BOTTOM LEFT: Early character designs for Punchy, Duke, Empty Vee, Destra, and Sykes. Pencils and inks on paper.
BOTTOM RIGHT: The series featured a comic within a comic, *Supersonic Espionage Boom*, starring Agent Boss Tempo drawn by Jim Lee in a detail of the pencils for issue 1, page 11. Pencils on art board.

Cover to the first issue of *The Intimates* (January 2005), featuring digital inks of Jim's pencils. Colors by Randy Mayor.

OPPOSITE: Punchy's power totem focused his powers for this cover to *The Intimates* #3 (March 2005). Colors by Randy Mayor.

The cover for *The Intimates* #2 (February 2005), again featuring digital inks of Jim's pencils. Colors by Randy Mayor.
BELOW: More character designs for the series. Pencils and inks on paper.

SLEEPER

SLEEPER is a series created by Ed Brubaker and Sean Phillips which played an integral part in the WildStorm Universe during the title's two-year run. An intriguing mix of spies, super-villainy, and noir sensibilities, it chronicled the efforts of Holden Carver to infiltrate and then move up the food chain of a major criminal organization. The result was a stylish, gritty book that kept readers guessing as it questioned all the accepted wisdoms and morals underpinning the genre.

Holden Carver has his own way of requesting privacy with Miss Misery. Pencils, inks, and Wite-Out on paper.
BELOW: Pencils, inks, ink wash, markers, and Wite-Out on art board.

THE NEW DYNAMIX

FROM writer Allen Warner and artist J.J. Kirby, this five-issue mini-series explored what had become of the many superpowered beings once prominent in the WildStorm Universe, and the reasons behind their increasingly rare appearances.

Variant cover to *The New Dynamix* #1 (May 2008), which was an homage to Jim's cover for *Uncanny X-Men* #268. Pencils, inks, and Wite-Out on art board.

The cover for *Fire from Heaven* #2 (July 1996). This issue marked Jim's first work with acclaimed writer Alan Moore. Inks by Scott Williams, colors by WildStorm FX.

FIRE FROM HEAVEN

Fire from Heaven was another major crossover event within the WildStorm landscape that centered on the appearance of Damocles, an insane villain from another reality, and his efforts to seize control of the WildStorm universe. This highly complex storyline included every title being published by the imprint at that time, and had a real and lasting impact upon many of those books and their main and secondary characters.

VERTIGO

> OH MAN... WHAT THE HELL WAS HE *THINKIN'* ANYWAY?

> WHO KNOWS...? SOME GUYS JUST *ALWAYS* GOT THEIR HEAD IN THE CLOUDS.

THE Vertigo line was the innovative new imprint borne out of DC's emerging line of mature concepts, language, and themes in titles edited by Vertigo's executive editor, Karen Berger. This movement began in the early 1980s, and the critical and sales successes of such titles as Grant Morrison's *Animal Man* and Neil Gaiman's *The Sandman*, as well as the growing popularity of graphic novels like *Watchmen* and *Batman: The Dark Knight Returns*, only served to speed its growth. As more creators were granted greater creative leeway in the subject matter that they could explore in existing and new titles, DC's mature titles enjoyed increased sales and critical acclaim.

By 1993 it became obvious to DC that they needed to differentiate this cutting-edge material from the mainstream DC Universe, leading to the establishment of the Vertigo imprint. While the first titles originated in the DC Universe, Vertigo quickly began establishing its own original titles, with a focus on stories set in new genres and art styles that were unique in the comics industry, and unlike anything else DC was publishing.

Ironically, it was Vertigo that hosted some of Jim Lee's earliest work published after the sale of WildStorm to DC. It was a challenge that Lee welcomed for his own creative reasons.

"I think any time you do something for Vertigo, you owe it to yourself, your style, to kind of mix it up a little bit. Doing that kind of more linear style that's more loosely inked, it's a lot of fun, and it gives sort of a grittier look to my more traditional, slick super-hero style."

FLINCH

OPPOSITE: Page five of the short tale "Rocket-Man" from the horror anthology *Flinch*, issue 1 (June 1999), based on a script by Richard Bruning. Colors by Tad Ehrlich.

THIS PAGE: "Rocket-Man" page eight from the same issue of *Flinch*. Colors by Tad Ehrlich.

TRANSMETROPOLITAN

Transmetropolitan #26 cover (October 1999). Written by Warren Ellis with art by Darick Robertson, *Transmetropolitan* is a darkly satirical socio-political science fiction series concerning the life and times of Spider Jerusalem (pictured), an acerbic investigative reporter with somewhat questionable morals and a complete lack of people skills. Colors by Tad Ehrlich.
OPPOSITE: *Transmetropolitan* #25 (September 1999) finished cover art. Colors by Tad Ehrlich.

PREACHER

Jim produced this pin-up for issue 50 of *Preacher*, the award-winning and acclaimed 66-issue series from writer Garth Ennis and artist Steve Dillon. This piece showcases the title's mix of religious themes with memorably eccentric, violent characters. Inks by Scott Williams, colors by Tad Ehrlich.

100 BULLETS

Jim's pin-up for issue 26, page nine of *100 Bullets*, a series created by Brian Azzarello and Eduardo Risso with a simple but endlessly intriguing premise: If you were given a briefcase containing a pistol, 100 untraceable bullets, a stack of cash, immunity from prosecution, and proof that someone had purposefully screwed up your life, would you pursue bloody revenge? Pencils, inks, and watercolors on art board.

AMERICAN VAMPIRE

Lee's pencil art for the variant cover of the inaugural issue of *American Vampire* (May 2010), the new horror series featuring scripting by Scott Snyder and Stephen King, with art by Rafael Albuquerque. Pencils on art board.
INSET: Keeping with the graphic look of the regular cover, Jim provided his own digital colors for this variant.

DMZ

The final art for the one-page "Matty + Zee" short-short tale from *DMZ* #50 (April 2010). *DMZ*, from writer Brian Wood with regular art duties performed by Riccardo Burchielli, tells the story of the Second American Civil War from the heart of one of its main battlegrounds—the island of Manhattan. Colors by Jeromy Cox.

WEIRD WAR TALES

ABOVE: Detail from the second page of the Garth Ennis-penned "Nosh and Barry and Eddie and Joe," an eight-page entry to the *Weird War Tales* one-shot horror anthology (April 2000). Colors by WildStorm FX.
BELOW: Another panel from page two of Jim and Garth's contribution to the *Weird War Tales* anthology. Colors by WildStorm FX.

DEATH

A portrait of the always-fetching personification of Death, sister to Morpheus, the King of Dreams, who first appeared in writer Neil Gaiman's celebrated and ground-breaking series *The Sandman*. Death's popularity as a character led to two eponymous series of her own. Pencils, inks, and Wite-Out on art board.

FIGHT FOR TOMORROW

RIGHT: Detail of Jim's very first painted color cover for DC. It appeared on the first installment of writer Brian Wood and penciller Denys Cowan's *Fight for Tomorrow* miniseries (November 2002), a gritty story about a martial artist trying to recover from the scars of child slavery. He must confront the demons of his past in his battle to save his lost lover. Pencils, inks, watercolors, and Wite-Out on art board.

BELOW: A quick layout of the full cover. "I had a lot of fun getting inspired by reading the first two issues and trying to come up with an image that captured the approach they were going for while still adding my 'style' into the mix." Pencils and markers on paper.

DC UNIVERSE ONLINE

DC *Universe Online* is an MMORPG (Massively Multiplayer Online Role-Playing Game), an online video game that can be played simultaneously by users around the globe. DCUO is unique in featuring the work of an established artist of Jim Lee's caliber—he serves as the game's executive creative director—and is being developed and published by Sony Online Entertainment. Its story was penned by Geoff Johns, the fan-favorite scripter who became DC's chief creative officer on the same day that Lee was installed as the company's co-publisher, with additional writing by long-time *Teen Titans* scribe Marv Wolfman. As its name implies, this game employs the entirety of DC Comics' rich history as fodder for its locales, characters, and gameplay.

"The great thing is that I actually have a team that I work with that I put together when we started the DC Universe Online game concept art project," Lee revealed. "That concept team, here at WildStorm, has been working with me on a lot of the redesigns. And now I've got them working on different characters. I think that the plan is to actually go through the entire DC Universe, produce a *Who's Who*, and look at each character and their look, tweak some and modify others, and maybe even create looks for other characters from scratch.

"It's going to be a long ongoing process, but it's something that we're completely excited by," he added. "And I think it's just one of the ways that I can help shape what the DC Universe is going to look like going forward, as co-publisher *and* as an artist."

CRAZY WATCHFUL TOUCHED/LOCO CONNIVING

ANGRY CONDESCENDING GLUTTONOUS EMBARRASSED

OPPOSITE TOP: Concept design for a pumped-up Doomsday. Pencils on art board.
OPPOSITE MIDDLE: Screen grabs of the final result: a 3D model of Doomsday. *DC Universe Online* 3D modeling produced by David Russ for Sony Online Entertainment.
OPPOSITE BOTTOM: Jim's redesign of Man-Bat. Pencils on art board.
TOP: Everything in *DC Universe Online* has to be designed from scratch, even facial expressions. Pencils on art board.
ABOVE: To the left, Lee's redesign for Wonder Woman's head; to the right, his orthographic drawings of the Amazonian princess warrior. Pencils on paper.
RIGHT: Metropolis, re-imagined for the virtual world of *DC Universe Online* in this early concept design. Pencils on art board.

A portrait of the comic medium's original trinity—Batman, Superman, and Wonder Woman—the conscience, heart, and soul of the DC Universe. This was an unused illustration to accompany the unveiling of DC's new logo. Pencils on art board.

RIGHT: Three of Jim's rough designs for the grouping of DC's heroic trio as intended to go around the company's new logo, which was unveiled on May 10, 2005. Pencils and markers on art board.

DC LOGO

LEE'S work on *DC Universe Online*, DC's highly anticipated, massively-multiplayer online game from Sony Online Entertainment, may be the most obvious of his efforts to explore the possibilities inherent to this digital age, but it's far from the only way Lee has helped raise the general public's awareness of DC Comics. For a number of years he has been tasked with creating visuals that have helped focus the world's attention upon the DC Universe.

Not coincidentally, these outreach programs dovetail perfectly with one of the primary challenges Lee has set for himself as co-publisher.

"I'd say on the executive, professional level, there's just a lot of stuff that's going on in the world of comics—and though I say 'the world of comics,' I'm talking about movies and games and interactive mediums....

"In the digital space alone, there are so many different opportunities to make your mark on the industry in a very positive way. So digital publishing is something that has become a passion of mine. And I'm just trying to figure out how we tackle those challenges and opportunities that digital publishing provides.

"There are a lot of things to be answered, and rather than be perplexed or confused, it's something that inspires me to wake up and ask, 'OK, how can we use all of this to our own diabolical creative needs and desires?'

"And I think being co-publisher at arguably the best comics publisher in North America definitely gives you opportunity and insight and the infrastructure to make things happen in meaningful ways. So I'm very, very excited by all of that."

Pencils for Jim's final character art for the new logo's reveal. Pencils on art board.

The finished logo, with DC's trinity. "The capes are really used to counterbalance the pose. So I'll typically draw the character in the pose, whether it's leaping, kneeling, hunching over, flying or whatever, with their arms and legs out. And then I'll balance the cape, the shape of the cape and the direction of the cape, against the direction and shape of the arms and those forms. It just creates, in my mind, a nicer composition of the cape against the human form." Inks by Scott Williams, colors by Alex Sinclair.

BATMAN BEGINS

BELOW: In the current multi-media-saturated age, it's a given that the release of any film based upon a comic book is vitally important to the character's parent company. But when it's the release of a major film which relaunches a franchise, it's even more important that all aspects of the film represent the publisher and its characters in the best of lights. All of which explains why Jim was chosen to create the visuals which introduced the movie-going public to the freshly-minted DC logo. Jim's storyboards for the "DC Spin"—the rapid animation which ran as part of the opening credits of *Batman Begins*. Pencils and markers on art board.
BOTTOM SEQUENCE ACROSS SPREAD, TOP TO BOTTOM: Pencil drafts of some of the DC Spin storyboards. Pencils on art board.
Those same storyboard images, in their inked stage. Pencils and inks on art board.
Screen captures of those images in their final, fully colored and animated form.

244

When DC Comics and the Converse sneakers company teamed up to create a special edition shoe in 2005, they asked Jim to design the new kicks. "Various designs for a licensed shoe I did for Converse. Fun to be a part of it." Pencils and markers on art board.

SUPERMAN RETURNS

BELOW: Having successfully helped to introduce the general public to the new DC logo with *Batman Begins*, Jim was the obvious choice to create the animated imagery leading up to the logo's appearance at the start of *Superman Returns*. Here are some unused images that he created for that film's opening credits. Pencils on art board.
BOTTOM: Rough layouts for those same credits. Pencils on art board.

CATWOMAN

Catwoman sketch. Pencils on paper.
ABOVE: Two rough Catwoman sketches, playing with her form and movement. Pencils on paper.
TOP LEFT: Cover art for *Catwoman: The Movie* #1 (2004). Jim was invited to the set of the film, and was able to draw Halle Berry in person. "Drawing from life is like walking a tightrope: there's a lot more spontaneity in the line and a lot of room for failure, but it's exhilarating. And it's hard to get the same results drawing from just photographs or from memory." Inks by Sandra Hope, colors by Alex Sinclair.
LEFT: Unused cover layout. Pencils on art board.

75TH ANNIVERSARY

ABOVE: For DC's 75th anniversary in 2010, Jim Lee was tasked with creating iconic shots of four major DC characters. These illustrations were used in logos for the anniversary, on books, and for other uses to mark DC's long relationship with its classic characters.
BELOW: Three of those same legendary characters, in their finished pencils stage. Pencils on art board.

The Caped Crusader. Pencils and inks on art board. Inks by Scott Williams.

PROMOTIONAL MATERIAL

ABOVE: "I use Google all the time for art reference and to find images to draw from, and it's been a real game-changer for me as an illustrator. So it was great to be able to do something with that company. They're definitely one of the more forward-thinking companies, and it was just cool to do something that had the DC characters."
Lee's Google logo design, released July 23, 2009 to mark the opening of the annual San Diego Comic-Con International. Pencils on Bristol board. Used with permission of Google, Inc.
BELOW: The finished art for the Google logo. Inks by Scott Williams, colors by Alex Sinclair. Used with permission of Google, Inc.

Created exclusively for Sony Online Entertainment in Austin, Texas. Inside, this Christmas card reads, "You choose." Pencils and inks on paper (2007).

GALLERY

GALLERY INDEX

Contributed for a limited-edition poster for 2003's "New York is Book Country" fair. Inks by Scott Williams, colors by Alex Sinclair.

The cover for issue 7 of *All Star Batman & Robin, The Boy Wonder* (November 2007). Inks by Scott Williams, colors by Alex Sinclair.

Jim's first published Batman cover was for *Batman: No Man's Land Gallery* #1 (July 1999), featuring Barbara Gordon, the Huntress, and Cassandra Cain as Batgirl. Pencils and inks on art board. Inks by Scott Williams.

The Dark Knight. Pencils, inks, ink wash, and Wite-Out on art board.

Voodoo of the WildC.A.T.s, being stalked by a Daemonite. Pencils, inks, and watercolors on art board (unfinished).

An ominous splash page from *Orion* #12 (May 2001). Pencils and inks on art board. Script by Walt Simonson, inks by Scott Williams.

A previously-unpublished piece by Jim of Cynthia, the youngest of the three witches who hosted DC's 1970s anthology horror comic *The Witching Hour*. Pencils and inks on art board. Inks by Scott Williams.

A variant cover to *Gen-Active* #3 (November 2000). Colors by Laura DePuy.

Super-spy Angela St. Grace strikes a pose with Go-Go, her sidekick, on the cover of *Codename: Knockout* #14 (August 2002), from Vertigo. Jim drew this over a layout by J. Scott Campbell. Inks by Sandra Hope, colors by WildStorm FX.

A pin-up of Samaritan from *Kurt Busiek's Astro City: A Visitor's Guide* #1 (December 2004). Inks by Richard Friend, colors by Alex Sinclair.

"Sometimes you get in the mood to do a streak of character sketches. I was doing various gals from the DC Universe and had never done a more polished take on Power Girl, so I went with it. Since I was going to draw her for an upcoming cover of *Infinite Crisis*... this was good practice, and you can see the changes I made from my first try to the take I used for the cover of *Infinite Crisis* #2." Pencils, inks, and Wite-Out on art board (2006).

An exclusive lithograph included with copies of the video game *Batman: The Rise of Sin Tzu* (2003). Jim co-created the character of Sin Tzu with writer Flint Dille for the game. Inks by Scott Williams, colors by Alex Sinclair.

The finished cover art for *WildC.A.T.s* #2 (September 1992). To highlight Void's powers, this was originally printed with a foil prism cover. Inks by Scott Williams, colors by Joe Chiodo and Digital Chameleon.

Jim completed this cover for *Wizard* #147 (January 2004) to promote WildStorm's *Coup d'État* series. In that issue, he was named *Wizard*'s Best Artist of the Year for the second time. Inks by Scott Williams, colors by Alex Sinclair.

Jim designed Green Lantern Kyle Rayner's new uniform, which debuted in this cover for *Green Lantern* volume three, #151 (July 2002). Inks by Scott Williams, colors by Alex Sinclair.

Three of the DCU's most popular heroines, Supergirl, Wonder Woman, and Batgirl, star in this pin-up created exclusively for the Warner Bros. Studio Store gallery, entitled "Heroines of the DC Universe." Prints were signed and numbered, and limited to 250 copies. Inks by Sandra Hope, colors by Alex Sinclair.

The Dark Knight surveys the mean streets of Gotham City in this piece from Batman's entry in *JLA-Z* #1 (November 2003), a guide to the characters of the DC Universe. Colors by Alex Sinclair.

Batman pauses briefly on his nightly patrol above the mean streets of Essen, Germany (October 2003). Pencils, inks, and Wite-Out on art board.

As Jim's *Hush* storyline took off, DC collected *Batman* #608 and #609 in *Batman: Hush Double Feature* (April 2003), with this all-new cover. Pencils on art board.

The Incredible Infringement Man from *MAD Magazine* #438 (February 2004). Pencils, inks, markers, and Wite-Out on art board.

This promotional piece saw print as the cover to *WildStorm Fine Arts Spotlight on WildCats* #1 (March 2008). Inks by Scott Williams, colors by Alex Sinclair.

Earth's various Green Lanterns fly into action on the cover of *Green Lantern* volume three, #150 (July 2002). Inks by Scott Williams, colors by Alex Sinclair.

The Bat and the Cat at play above the mean streets of Gotham City, in this pre-*Hush* sketch by Jim. Pencils, inks, ink wash, markers, and Wite-Out on art board.

Who would win? The obsessive brilliance of Batman or the unearthly powers of Superman? This 2007 pin-up by Jim dares not answer this eternal question. Colors by Alex Sinclair.

The *Infinite Crisis* #1 (December 2005) variant cover features DC's trinity, and some of their friends and foes. Inks by Sandra Hope, colors by Alex Sinclair.

Pages 264-265: Samaritan and Astro City ™ & © 2010 Juke Box Productions.

LEGION OF SUPER-HEROES

THEY are known as the Legion of Super-Heroes. Sworn to serve and protect the citizens of the United Planets, their stories are as scattered and varied as the worlds they represent.

It all started when a trio of time-travelling teens from the 30th century, inspired by the legendary exploits of a young Superman, established a "super-hero club." Quickly it matured into a vast organization composed of super-powered youths drawn from the many regions of known space, each Legionnaire dedicated to the establishment and maintenance of peace and justice.

Written by Otto Binder and drawn by Al Plastino, the Legion's first adventure was published in April 1958. Over the following decades the series has served as an important source of inspiration for innumerable readers... and generations of aspiring writers and artists, including Paul Levitz and Jim Lee, whose mutual childhood dream of working in comics was sparked in large part by their love of the Legion's exploits.

OPPOSITE: Early character design sketches for members of the Legion of Super-Heroes. Pencils, inks, markers, and Wite-Out on paper (2003).
THIS PAGE: Wearing an update on her classic 1970s costume, Saturn Girl prepares for action on the variant cover of *Legion of Super-Heroes* #1 (July 2010), which featured the return of fan-favorite writer Paul Levitz. Inks by Scott Williams, colors by Alex Sinclair.

Lee was especially pleased to draw an all-new, exclusive Legion tale for *Icons*.

"Of all the people at DC, I've known Paul the longest. And I was a huge fan of the Legion growing up, so being able to work with one of the seminal creative voices of DC, and work with him on characters that really defined much of his career, it's exciting."

The story came about when Levitz was stepping down as publisher of DC Comics, a role Lee would help to fill. And it was plotted just before Levitz returned to the Legion full-time, as the writer of their ongoing adventures.

BELOW AND RIGHT: Jim's rough layouts for, clockwise from below, pages one and two, three and four, and five and six of "A Moment in Time" (2010). Pencils on art board.
BOTTOM AND OPPOSITE: Finished pencils for those same pages (2010). Pencils on art board.

ONE SUCH CONSTRUCTION IS HIDDEN HERE, DEEP IN THE HEADQUARTERS OF THE

LEGION
OF SUPER-HEROES

A CELEBRATION OF JIM LEE PENCILLER
WITH THE ASSISTANCE OF PAUL LEVITZ WRITER
SCOTT WILLIAMS INKER ALEX SINCLAIR COLORIST
SAL CIPRIANO LETTERER AND STEVE KORTE EDITOR
SPECIAL THANKS TO JOEL GOMEZ

In an infinite universe, there are infinite possibilities. Life can be dominated by the pursuit of survival, discovery, or even creation. By the 31st century, we may explore **all** those possibilities, and achieve the potential inherent in each of us...

...we may be served by devices that now can only be conjured by an artist's imagination...even machines that can create **miracles**.

A MOMENT IN TIME

With appearances by Ultra Boy, Saturn Girl, Wildfire, Phantom Girl, Lightning Lad, Dawnstar, Mon-El, The Kents, Dream Girl, Star Boy, Brainiac 5 and a few surprise guests!

WE'RE HOME!

YOU MADE IT--YOU BROKE OUT OF THE TIME TRAPPER'S POCKET UNIVERSE!

BARELY.

HEY, ISN'T ANYONE HAPPY TO SEE ME?

AW, GO DEBRIEF A DATABANK, YOU OL' BAG OF ENERGY.

TINYA AND I HAVE SOME CATCHING UP TO DO!

YOU BET, BIG GUY.

LATER, LEGIONNAIRES.

DO NOT MIND ULTRA BOY, WILDFIRE. SOME OF US ARE GLAD TO SEE YOU.

THE DC COMICS AND WILDSTORM ART OF JIM LEE
A SELECT BIBLIOGRAPHY

JIM LEE AS A MAJOR CONTRIBUTOR
Absolute Batman: Hush. Jeph Loeb, Jim Lee, and various. New York, NY: DC Comics, 2005.
Absolute Superman: For Tomorrow. Brian Azzarello, Jim Lee, and various. New York, NY: DC Comics, 2009.
Alan Moore's Complete WildC.A.T.s. Alan Moore, Jim Lee, Travis Charest, and various. La Jolla, CA: WildStorm, 2007.
All Star Batman & Robin, The Boy Wonder volume 1. Frank Miller, Jim Lee, and various. New York, NY: DC Comics, 2008.
Batman: Hush. Jeph Loeb, Jim Lee, and various. New York, NY: DC Comics, 2009.
Coup d'État. Ed Brubaker, Joe Casey, Robbie Morrison, Micah Wright, Jim Lee, Carlos D'Anda, Alé Garza, Whilce Portacio, and various. La Jolla, CA: WildStorm, 2004.
Deathblow: Sinners and Saints. Brandon Choi, Jim Lee, Tim Sale, and various. La Jolla, CA: WildStorm, 1999.
Divine Right: The Adventures of Max Faraday: Book One. Jim Lee, Scott Williams, and various. La Jolla, CA: WildStorm, 2002.
Divine Right: The Adventures of Max Faraday: Book Two. Jim Lee, Scott Williams, and various. La Jolla, CA: WildStorm, 2002.
Gen[13]: Who They Are and How They Came to Be. Brandon Choi, Jim Lee, J. Scott Campbell, and various. La Jolla, CA: WildStorm, 2006.
Gen[13]: Starting Over. Brandon Choi, Jim Lee, J. Scott Campbell, and various. La Jolla, CA: WildStorm, 1999.
James Robinson's Complete WildC.A.T.s. James Robinson, Jim Lee, Travis Charest, and various. La Jolla, CA: WildStorm, 2009.
Just Imagine Stan Lee Creating the DC Universe, Book One. Stan Lee, Joe Kubert, Jim Lee, John Buscema, Dave Gibbons, and various. New York, NY: DC Comics, 2002.
Stormwatch Volume Two: Lightning Strikes. Warren Ellis, Jim Lee, Tom Raney, and various. La Jolla, CA: WildStorm, 2000.
Superman: For Tomorrow, volume one. Brian Azzarello, Jim Lee, and various. New York, NY: DC Comics, 2005.
Superman: For Tomorrow, volume two. Brian Azzarello, Jim Lee, and various. New York, NY: DC Comics, 2005.
WildC.A.T.s/Cyberforce: Killer Instinct. Brandon Choi, Jim Lee, Marc Silvestri, and various. La Jolla, CA: WildStorm, 2004.
WildStorm Rising. James Robinson, Ron Marz, Jim Lee, Barry Windsor-Smith, and various. Anaheim, CA: Image, 1996.

JIM LEE AS A CONTRIBUTOR:
Batman: Black and White, volume one. Jim Lee and various. New York, NY: DC Comics, 2000.
Batman: Black and White, volume two. Warren Ellis, Jim Lee, and various. New York, NY: DC Comics, 2003.
Batman Cover to Cover: The Greatest Comic Book Covers of the Dark Knight. Frank Miller, Jim Lee, Tim Sale, and various. New York, NY: DC Comics, 2005.
Catwoman: The Movie and Other Cat Tales. Chuck Austin, Doug Moench, Steven Grant, Tom Derenick, Adam DeKraker, Jim Lee, and various. New York, NY: DC Comics, 2004.
Gen[13]: Collected Edition. J. Scott Campbell, Jim Lee, Brandon Choi, and various. La Jolla, CA: WildStorm, 1994.
Gen[13]: Meanwhile. Adam Warren, J. Scott Campbell, Jim Lee, and various. La Jolla, CA: WildStorm, 2003.
Heroes, volume one. Chuck Kim, Jim Lee, Tim Sale, and various. La Jolla, CA: WildStorm, 2007.
Superman Cover to Cover. Joe Shuster, Neal Adams, Curt Swan, Jim Lee, and various. New York, NY: DC Comics, 2006.

OPPOSITE: *Absolute Batman: Hush* pin-up (2005). Pencils and inks on art board.
PAGE 296: Rough layout for an early *Icons* cover concept going in a "more graphic with art elements" direction while showing "a mesh of traditional comic art and something more 'designy.'" Featuring, from left to right, Batman, Caitlin Fairchild of Gen[13], Superman, Grifter of the WildC.A.T.s, and Saturn Girl of the Legion of Super-Heroes. Pencils on art board (2008).
FRONT ENDPAPERS: *All Star Batman & Robin* #6 (September 2007), pages 18-19. Pencils on art board.
BACK ENDPAPERS: *Superman* #208 (October 2004), pages 18-19. Pencils on art board.

DEDICATION

I dedicate this book to my devoted wife, Carla, and all of my lovely kids and family and friends who have supported me and put up with my obsessive need to work from day one. And to my fans: many creators talk about creating first for themselves but for me—I do this all for you guys.

ACKNOWLEDGEMENTS

This book was a long (too long!) journey in the making and wouldn't be possible without the never-ending support and combined efforts of the two editorial teams from DC Comics and Titan Publishing, organized and led by the DC's Steve Korte. Gentleman Steve and the tireless, unflappable John Morgan were there from the beginning, fearlessly shepherding this book along from inception to publication. This project could have died several deaths during its genesis but they carried it through to the end with artistry and aplomb. A much deserved round of applause (and drinks!) to Stephen Saffel, Jo Boylett and Katy Wild as well for their steadfast perseverance and patience in seeing this book through print. Their commitment to quality was always appreciated and is evident on every single page. On that note, this collection does not exist without Art Director Martin Stiff's incredible work. His clean lines make for an amazingly sharp presentation and handsome design; never has my work looked so snappy, smashing and smart.

My undying thanks also go out to scribe Bill Baker for putting words to all of the images and for the amazing number of hours he logged in, conducting interviews and editing my ramblings down into cohesive thoughts. To grand-art-master Eddy Choi for his sheer dedication in not only locating all the hidden gems but for documenting and cataloging all the addendums and miscellaneous notes for this massive tome. His contributions make this book the ultimate collection.

A big high five to Paul Levitz for sharing his love of DC and its legendary pantheon of characters. His voice truly makes the Legion come to life. Finally, this book wouldn't be possible without the continued sacrifices and support from inker-extraordinaire Scott Williams, coloristo-perfecto Alex Sinclair and the many talented and dedicated people who've walked through the halls of WildStorm in one form or another. They have always pushed me to be my best and helped make this one artist's work stand out from the rest.

All the best—

Jim Lee

AUTHOR'S DEDICATION

Bill Baker would like to dedicate this book to Jim Lee, his many fans, and to you, the reader.
Without all of you, this simply wouldn't have been possible.

AUTHOR'S ACKNOWLEDGEMENTS

Bill Baker would like to thank…

The good folks at DC Comics, particularly Steve Korte, Paul Levitz, John Morgan, and Andrea Shochet. All the fine people at Titan, including Elizabeth Bennett, Vivian Cheung, Nick Landau, and Martin Stiff. The whole WildStorm crew, with extra appreciation to Scott Williams and Alex Sinclair for their thoughts and time. Dennis Barger and the staff of Wonder World Comics, for supplying key reference material when it was needed most. The three people who were instrumental in making this project work: Eddy Choi, who always went above and beyond, Steve Saffel, whose steady editorial guidance and sage advice proved invaluable, and Jo Boylett, without whose tireless work and incredible attention to detail this book would not exist. Finally, Jim Lee, for his constant patience, kindness and generosity of spirit, as well as his willingness to share that rarest and most precious of commodities—his time.